50 GEI Somerset

ANDREW POWELL-THOMAS

AMBERLEY

For Laura, James and Ryan with love.
Here's to all the Somerset adventures we have already had and all the ones
yet to come!

First published 2019

Amberley Publishing
The Hill, Stroud
Gloucestershire, GL5 4EP

www.amberley-books.com

British Library Cataloguing in Publication Data.
A catalogue record for this book is available from the British Library.

ISBN 978 1 4456 8551 9 (paperback)
ISBN 978 1 4456 8552 6 (ebook)

Origination by Amberley Publishing.

Printed in Great Britain.

Contents

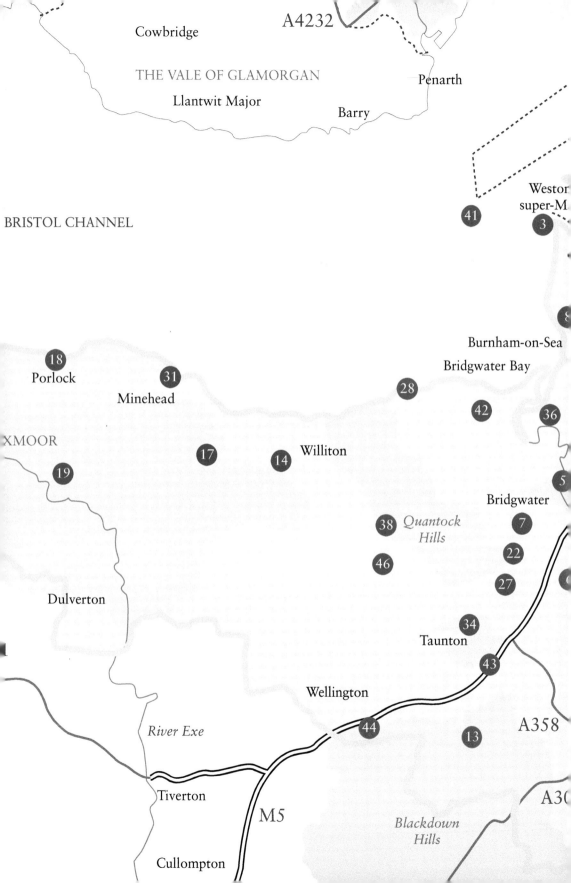

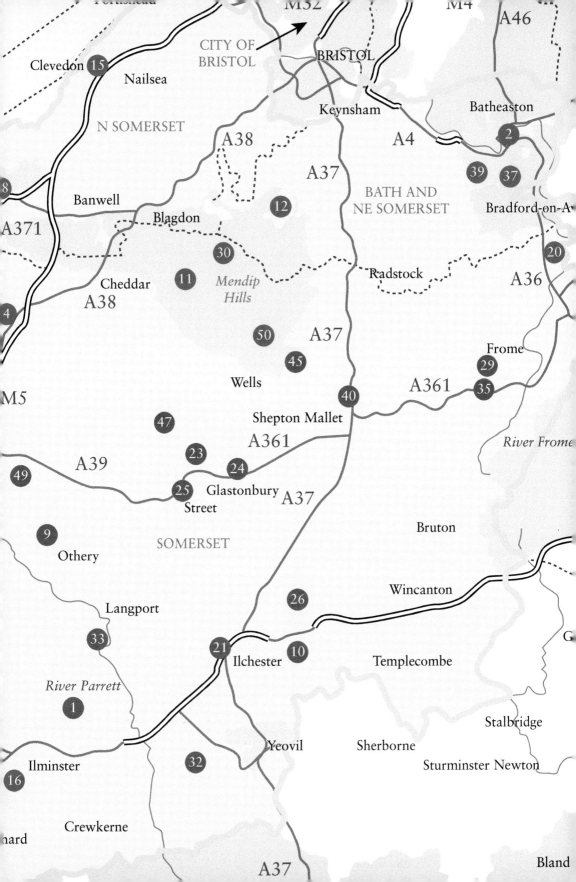

Introduction

Somerset, the seventh largest county in the United Kingdom, is often thought of as a rural backwater with little more than farmland and a few towns to shout about, but, as the place I have called home for the last seven years, I have discovered that this couldn't be further from the truth! With grand castles and abbeys, a range of natural beauty spots and interesting museums, and historic buildings and fabulous festivals, Somerset has something to keep the whole family entertained. There are obviously far more gems in Somerset than the fifty in this book, and the biggest challenge for me was deciding which ones to include. As someone with a young family, we are constantly finding new places to visit and explore and, as such, I have tried to include a range of gems that will appeal to everyone, young and old, active and relaxing. It is one thing to read about places and look at some pictures but an entirely different thing to explore them yourself, and I would hope that if nothing else, this book encourages you go and explore some of these wonderful sites!

1. Barrington Court

The National Trust-owned Barrington Court is a rather grand Tudor manor house near Ilminster. Originally built in the 1550s, it has been owned, inherited and sold many times over the course of its history, and by 1745 it entered a phase of decline. After years of neglect and poor maintenance, it was gutted by fire in the early nineteenth century and lay derelict until the National Trust purchased the property in 1907. Not quite realising how expensive repairs would be, a fledgling National Trust leased the property in the 1920s to Colonel Abram Lyle, of Tate & Lyle fame, who renovated the house and gardens with his own extensive personal fortune. He used his own personal collection of historic woodwork to refurbish the inside with the 'long gallery' and a beautiful staircase that he saved from a Scottish castle being two of the main highlights. After exploring the house and taking a well-deserved break in the tearoom, an afternoon stroll around the walled gardens, orchards and pergolas is a must, as they are well maintained and give you a snapshot of what life was like living in Barrington Court.

The grand exterior of Barrington Court. (Courtesy of Muffinn CC BY 2.0)

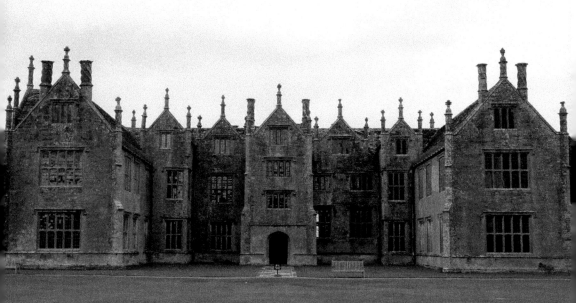

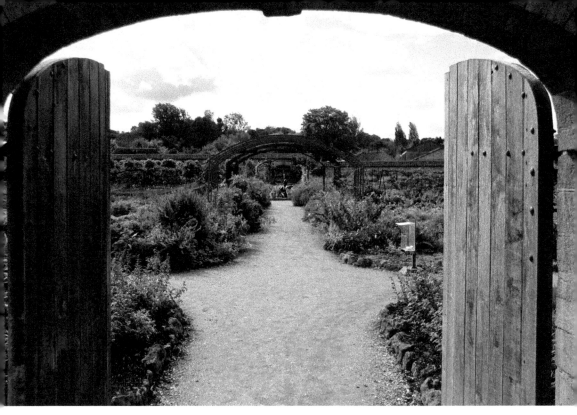

A stunning entrance to one of the many gardens. (Courtesy of Muffinn CC BY 2.0)

2. Bath

The largest city in Somerset is a tourist hotspot for anyone visiting the West Country. In 1987 Bath became a listed UNESCO World Heritage Site for its Georgian architecture and town planning, as well as its Roman archaeology, and a walk around the streets justifies this status. As you meander through the city centre it is impossible not to be impressed with the grand, imposing and elegant structures that are seemingly everywhere. The Georgian crescents, squares and circus, with buildings constructed uniformly out of local honey-coloured limestone, all have attractive views where the natural landscape has been used to make this a spacious and beautiful city. The city was founded by the Romans, who built a temple and baths (see entry 39 for specific details) due to the hot springs that were located there, and over the centuries Bath became popular as a spa town. The Bath you see now was planned and built in the eighteenth century with many buildings having grand façades, the most spectacular of which is the Royal Crescent and its numerous Ionic columns separating the town houses. In the city centre itself, the beautiful Pulteney Bridge sits astride the River Avon and is one of the few examples in Europe of a bridge specifically designed to also be a shopping arcade. Bath has long been viewed as a cultural and literary centre and, as such, over the weekend of 25–27 April

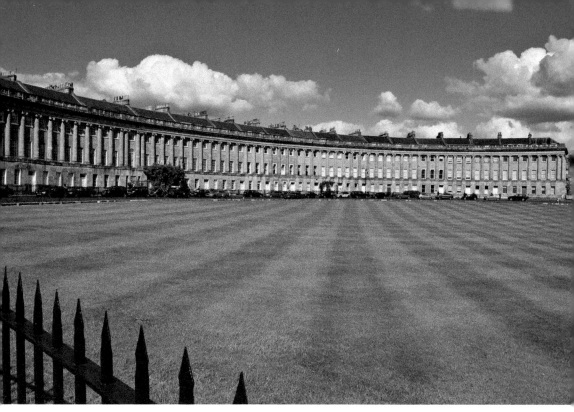

Above: It is hard not to be impressed by the rather grand Royal Crescent. (Courtesy of Jen Hunter CC BY 2.0)

Below: Pulteney Bridge and the River Avon. (Courtesy of Pedro Szekely CC BY-SA 2.0)

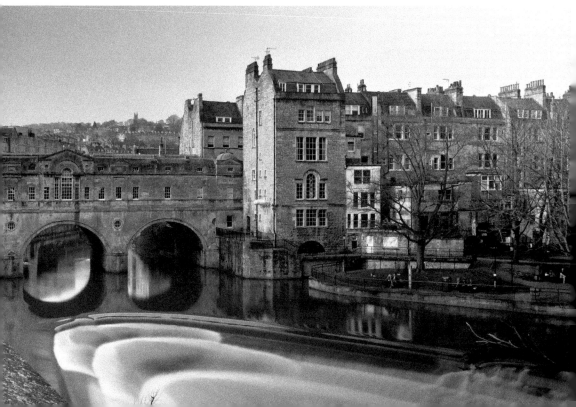

1942, Bath was heavily bombed by Nazi Germany as part of their Baedeker raids, where cities of cultural significance were targeted in response to the growing success of the RAF's own raids in Germany. Over seventy-five aircraft dropped bombs on Bath that weekend, resulting in over 400 civilians being killed, over 1,000 injured and a staggering 19,000 buildings being affected. Like all cities, Bath has undergone redevelopment in recent years, but it is so pleasing that it seems it is all in keeping with the architectural designs of the past, and it is this grand step back in time that makes Bath a delightful place to visit. A final footnote is that it is not surprising to know that there are a number of significant people associated with the city including William Pitt the Younger, Mary Shelley, Jacqueline Wilson, Mary Berry and Roger Bannister, as well as Charles Dickins, who was also a frequent visitor.

3. Brean Down

The natural outcrop of land at Brean Down has to be one of Somerset's most stunning vistas. Arriving at the car park after following the long coastal road, you can either head to the vast expanse of beach for some relaxation or prepare yourself for the 200 or more steps up to sample the spectacular panorama. Although steep and tiring, even for the experienced walker, the hike up is worth it as you can see for miles and miles around, with plenty of open space for a well-deserved picnic among the bluebells, birds and the occasional brave goat! It isn't surprising to know

Lewis gun emplacements from the Second World War overlooking the beach of Weston-super-Mare.

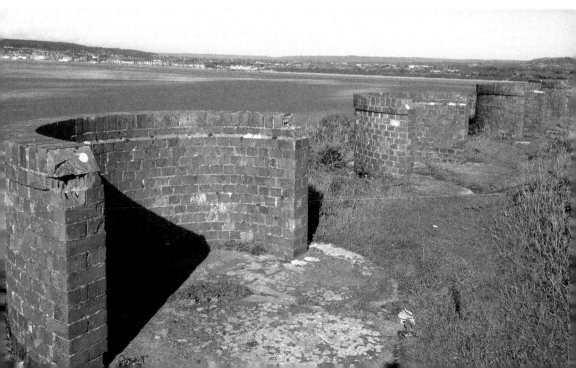

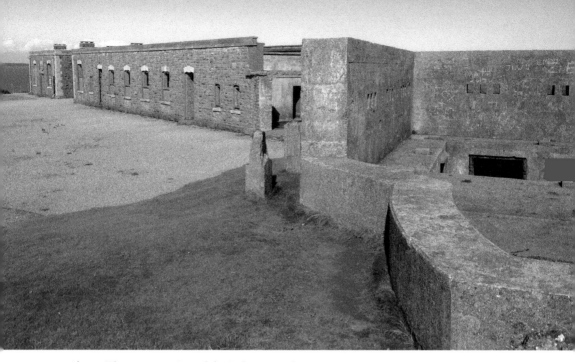

Above: The vast remains of the Palmerston fort.

Below: At the very end of Brean Down are the remains of the test launch site for experimental weapons.

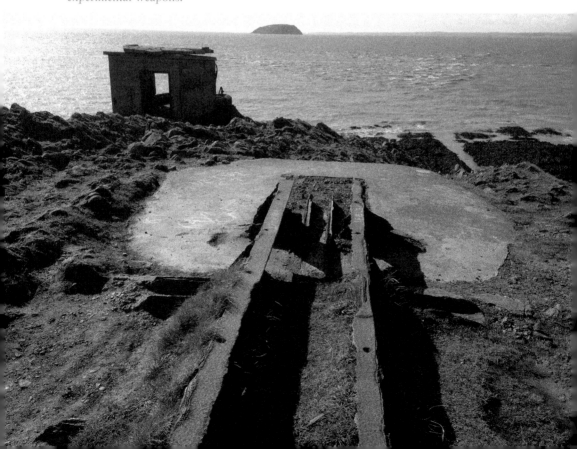

that humans have been using the site for a long time, no doubt due to its prominent position, with Iron Age artefacts being among the earliest examples, along with significant earthworks that indicate a permanent settlement. In 1864, a Palmerston Fort was built in response to Queen Victoria's concerns about the strength of the French Navy, and this position helped protect the approaches to both Bristol and Cardiff. The peninsula and its fort were then used again in the Second World War as it became a coastal battery, as well as a test launch site for experimental weapons and rockets. These structures still remain at the very end of Brean Down and are just another reason to visit this breathtaking place.

4. Brent Knoll

Brent Knoll is an Iron Age hill fort that is over 100 metres high and has had human settlements on it since before 2,000 BC. Well over a hectare in size, it has a single ditch around it as well as a range of ramparts. Located to the south of Burnham-on-Sea and looked after by the National Trust, it dwarfs the landscape surrounding it and is easily visible from the M5 motorway. There is evidence that the Romans used the site. Coins, roof tiles and painted wall plaster have all been found, and these items are on display at museums in Taunton, Bridgwater and Weston-super-Mare. The Romans called it 'The mount of Frogs' as, at the time, it was an island surrounded by marshland before the

The Iron Age hill fort of Brent Knoll.

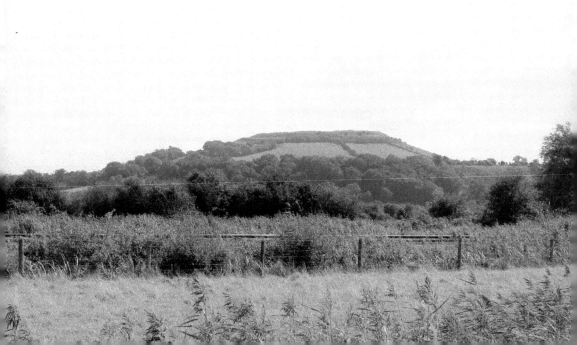

Somerset Levels were drained. The knoll is also thought to be the site of the AD 875 battle between the Anglo-Saxon kingdom of Wessex and the Great Viking (Heathen) Army. It is no surprise that Brent Knoll was used during the Second World War as an anti-aircraft gun emplacement and today it is a popular destination for ramblers and those looking to blow away the cobwebs. With the view at the top, a free car park and a pub in the village, it is easy to while away a blissful few hours.

5. Bridgwater

The largest town in the Sedgemoor district, Bridgwater is located just 10 miles from the mouth of the primary waterway in Somerset, the River Parrett, and has a long and established heritage. It was mentioned in the Domesday Book due to its standing as a trading centre, and in 1200 King John granted a charter to construct Bridgwater Castle, which provided the Lord of the Manor of Bridgwater, William Brewer, a grand and imposing base with which to expand the town – and his own wealth! Over the century's the castle's fortunes waned and very little remains of this once vast stronghold, save for a small portion of the wall, the water gate located on West Quay and some streets named after the parts of the castle they now occupy. As the birthplace of the famed Admiral Robert Blake, a walk around the town sees many tributes to the man dubbed the 'Father of the Royal Navy' with statues, shops and

The beautiful Victorian bridge built in 1883. (Courtesy of Alison Day CC BY-ND 2.0)

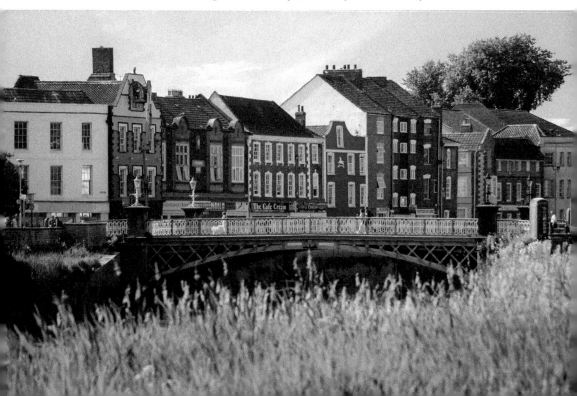

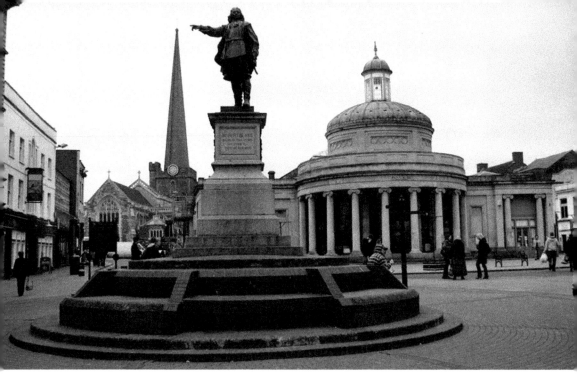

Above: A statue of Robert Blake in Bridgwater town centre. (Courtesy of Robert Cutts CC BY 2.0)

Below: A 4-metre section of Bridgwater Castle still remains.

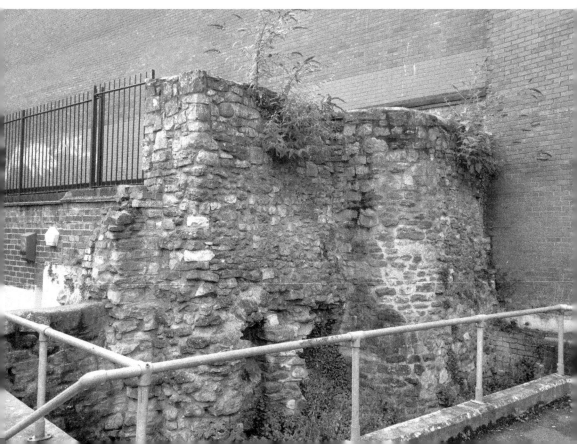

schools bearing his name. The house he was born in is now the Grade II listed Blake Museum, which is located close to the centre of the town where there are a number of impressive building façades such as the library and the Corn Exchange. The tidal River Parrett has a delightful ironwork Victorian era bridge over it and along the banks of the river are some hoists and cranes from the town's past. Bridgwater Docks, which in its heyday was a hive of activity, is today well worth a stroll around with its mixture of new buildings and remnants of more hectic times. Bridgwater & Taunton Canal also starts its journey from these docks, which is where we head next.

6. Bridgwater & Taunton Canal

From Bridgwater docks, the Bridgwater & Taunton Canal meanders for the next 12 miles or so, linking the River Parrett to the River Tone. Originally opened in 1827, the canal saw large amounts of coal and stone being transported, but as the competition from railways increased the canal went into decline. During the Second World War, the canal itself was part of the Taunton Stop Line; a defensive line designed to repel any German advance in the West Country. At over 12 feet wide (3.5 metres), it would be an immoveable object that would need to be crossed, and, as such, all eleven

Maunsel Lock. (Courtesy of Secret Somerset CC BY 2.0)

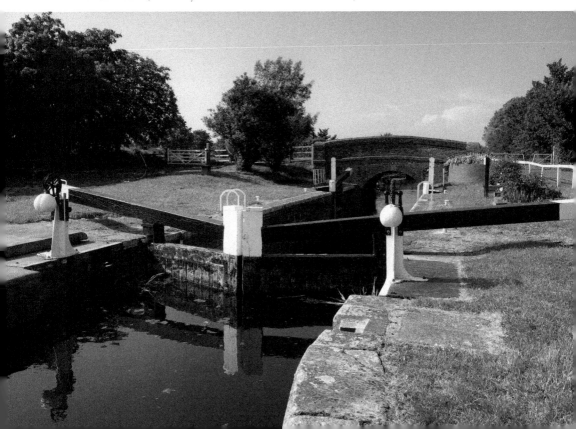

Left: Demolition chambers from the Second World War are still visible under the bridges.

Below: A pillbox still stands guard over the Bridgwater & Taunton Canal.

of the existing brick-built permanent bridges were mined with demolition chambers that would be ignited should they look like being compromised. Although now filled in, these chambers, and a large number of pillboxes, are still visible today and the freshwater canal itself is a haven for a wide array of wildlife, both in and out of the water. With well-maintained towpaths, a few well-positioned pubs and a lovely tearoom at the Maunsel Lock Canal Centre, a walk along the canal is an absolute must! At the Canal Centre it is also possible to hire a barge and while-away a few hours punting up and down at a leisurely pace, but whereever you explore along the canal, you will find it relaxing and enjoyable. With seven working locks to marvel at, the canal's towpaths form part of the Sustrans National Cycle Network, which connects Bath and Cornwall and is a busy route for cyclists. The canal is also home to the 'Somerset Space Walk', a scale model of the solar system that has the planets stationed along the towpath in both directions, starting with the sun at Maunsel Lock.

7. Bridgwater Carnival

Across the county, carnival clubs spend the year designing and making their floats ready for one of the main highlights of the social calendar – carnival season! From September to November, towns and villages across Somerset host a series

One of the carts at the Bridgwater Carnival. (Courtesy of Al Howat CC BY-ND 2.0)

Squibbing at the Bridgwater Carnival. (Courtesy of Martin Warren CC BY 2.0)

of carnivals that showcase the very best in amateur endeavour and entertainment, the highlight of which is the Bridgwater Guy Fawkes Carnival, which is now held on the first Saturday of November. The origins of the carnival date back to the Gunpowder Plot of 1605, where the staunchly Protestant town of Bridgwater revelled in the opportunity to commemorate the annual anniversary and seemingly did so more than anyone else! As a result, this is now one of the world's largest illuminated winter carnival processions, with hundreds of floats meandering along the two-hour-long route much to the excitement of the thousands who travel from near and far to experience this magical evening of entertainment. With the smell of hot dogs and candy floss in the air, the sound of music pulsating through the streets and the thousands of coloured light bulbs, dazzling costumes and special effects, it is a wonderful way to raise money for local groups. Bridgwater is also the only carnival to be followed by the very old tradition of 'squibbing', which is the simultaneous firing of large fireworks. Around 150 'squibbers' line the high street holding aloft their lit squibs at the same time, illuminating the town in one great trail of fire, which marks the end of the Bridgwater festivities. The whole event has to be seen to be believed and regardless of the weather it is an event that will live long in the memory.

8. Burnham-on-Sea

The seaside town of Burnham-on-Sea, which sits at the mouth of the River Parrett, was merely a small fishing village until the late eighteenth century when its popularity as a seaside resort saw its population grow. Notable for its long stretches of sand, which attract many visitors, Burnham also has extensive mudflats that over the years have posed a danger to shipping and individuals. Many lighthouses have been built here, the first of which is known as 'the Round Tower' and now only has two stories remaining, and the 'High Lighthouse', at 34 metres tall, is now a Grade II listed building and available for holiday lets. The current working lighthouse, the 'lighthouse on legs', stands in isolation on the beach, a place where the tide can go out miles and miles, exposing some of the many shipwrecks that have happened over the years on the Gore Sands. Like all good seaside resorts, Burnham has the obligatory pier located along the Esplanade, although the concrete structure completed in 1914 has the dubious claim of being Britain's shortest pier!

The old lighthouse on the beach at Burnham-on-Sea. (Courtesy of Les Haines CC BY 2.0)

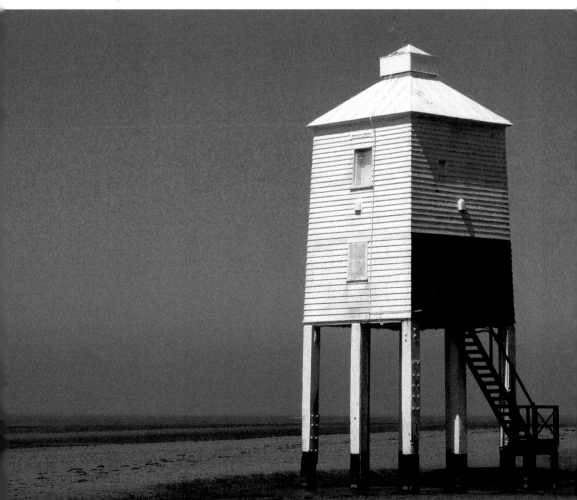

The vast beach and the 'shortest pier in Britain' at Burnham is perfect for a family day out.

9. Burrow Mump

Burrow Mump, in the small village of Burrowbridge, is the perfect spot for a picnic that overlooks miles of the surrounding countryside. The short climb to the top of the hill and the ruins of St Michael's Church, built in 1793, are easily achieved at this strategic point along the river. The location has been called 'King Alfred's Fort' but there is no firm evidence of any link to King Alfred the Great or of it ever being a fort. There was a medieval church occupying the same position as the current ruins, also dedicated to St Michael, which was used by Royalist troops during the Monmouth Rebellion of 1685. The site passed through different hands over the years and was given to the National Trust by Major Alexander Gould Barrett in 1946 to serve as a memorial to the 11,281 men and women of Somerset who died during the Second World War. Interestingly, the church stands on a ley line connecting other St Michael's churches at Othery and Glastonbury Tor, and from the top it is possible to look for miles in all directions over the Somerset Levels. With villages, lakes and fields all visible, the views can be spectacular.

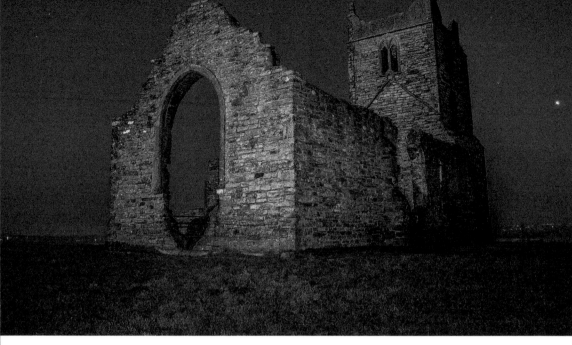

Above: Burrow Mump by night. (Courtesy of Mark Bradshaw CC BY 2.0)

Below: The plaque at Burrow Mump commemorating those who fought during the Second World War. (Courtesy of Robert Cutts CC BY 2.0)

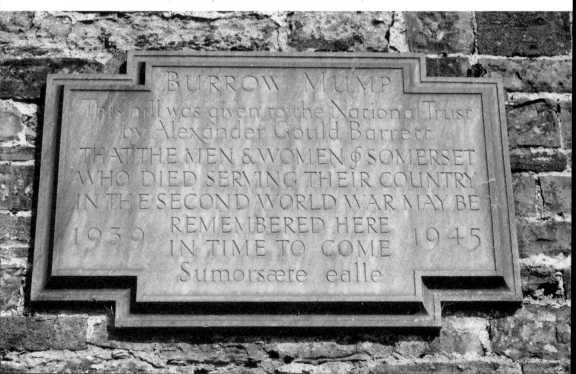

Was this Camelot? The elevated position of Cadbury Castle. (Courtesy of Hugh Llewelyn CC BY 2.0)

10. Cadbury Castle

Around 5 miles from Yeovil in the south Somerset countryside is a Bronze and Iron Age hill fort that covers 18 acres and still has its terraced defensive earthworks in situ. Located at the top of Cadbury Hill, Cadbury Castle has been excavated a number of times and this is still ongoing in places. Artefacts from a number of periods have been unearthed and it is thought to have been later used by the Romans as a military barracks and refortified in the Middle Ages. Intriguingly, the site was once known as 'Camalet' – with some believing that this is the site of King Arthur's Camelot! Whether it was or not remains to be seen, but anyone visiting this underdeveloped wilderness will certainly enjoy the marvellous views that make the steep and sometimes rugged walk to the top worth it.

11. Cheddar Gorge

Thousands of years in the making, the nature, wildlife, history and adventure activities at Cheddar Gorge and caves makes this one of Somerset's most visited attractions. Lying at the edge of the Mendip Hills, Cheddar Gorge cuts spectacularly into the limestone, creating near-vertical cliffs that are just over 130 metre in depth

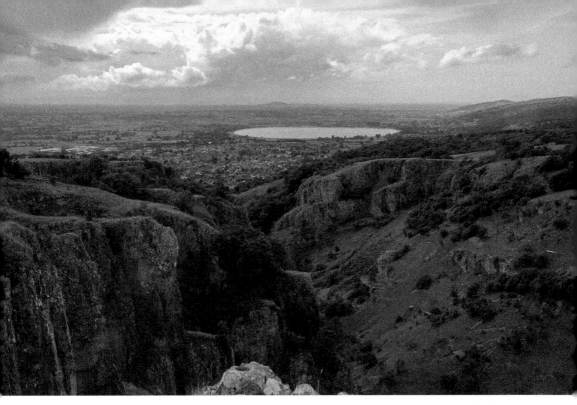

Above: Atop Cheddar Gorge the views are simply stunning. (Courtesy of Anup Shah CC BY-SA 2.0)

Below: Gough's Cave at Cheddar Gorge. (Courtesy of Anup Shah CC BY-SA 2.0)

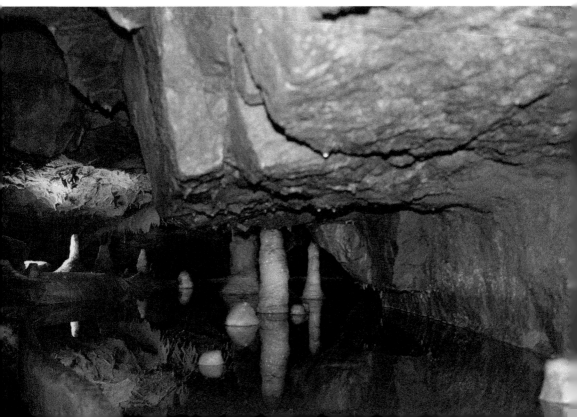

at their maximum. Ascending the 274 steps of 'Jacob's Ladder' is the quickest way to the clifftops, where a watchtower provides breath-taking 360-degree views of the village and the countryside for miles around. A 3-mile walk along the top provides many more wonderful views as well as the chance to see an abundance of wildlife, including the extremely rare greater horseshoe bat and great crested newts, in this Special Area for Conservation. In the Cheddar show caves, excavated in the late nineteenth century for Victorian exploration and tourism, there are huge caverns, amazing rock formations and incredible stalagmites and stalactites to see. 'Gough's Cave' is also the location of 'Cheddar Man', the oldest complete human skeleton ever found in Britain, who lived in the area over 9,000 years ago! In fact, our ancestors lived in the caves at the end of the last Ice Age over 14,000 years ago, with a number of artefacts being found by archaeologists over the years and now on display in the Museum of Prehistory. For the more adventurous, it is not surprising to find a whole range of rock climbing and caving opportunities for all skill levels to participate in.

12. Chew Valley Lake

Located on the northern edge of the Mendip Hills and around 10 miles away from Cheddar Gorge, Chew Valley Lake is a relatively recently established haven for wildlife. The largest artificial lake in the south-west, it was opened in 1956 by Queen Elizabeth II as a reservoir to provide the drinking water for Bristol and the surrounding area. Covering over 1,000 acres, it has become a Site of Special Scientific Interest and a Special Protection area thanks to the variety of plants, insects and birds

Sunset over Chew Valley Lake. (Courtesy of Stewart Black CC BY 2.0)

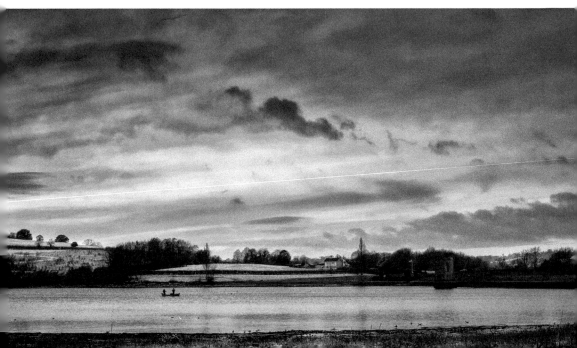

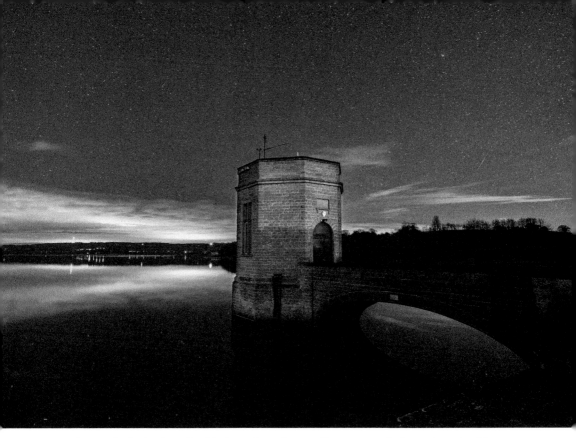

Above: The lack of artificial light makes Chew Valley a magical place when the skies are clear. (Courtesy of Adam Court CC BY 2.0)

Below: There is an abundance of wildlife to be spotted in, out and on the water. (Courtesy of Snapp3r CC BY-ND 2.0)

that reside there. With over 260 species of bird having been recorded, it has become a national centre for birdwatching. In particular, the spring and autumn migration sees a huge number of different flocks at the lake, while it is also an important site for species during wintering. With a wetland reserve established on the opposite side to the causeway, an abundance of fish and the vegetation around the lake providing a thriving habitat for insects and animals, this is a nature reserve that has developed fast! On the lake itself it is possible to go sailing or fishing and with its vast expanses of open space and fresh air, it's not surprising to see why so many people come here to get away from it all. The perfect place for a picnic, walk, bike ride (especially for youngsters who are still learning!) and being at one with nature, Chew Valley Lake is well worth a visit.

13. Churchstanton

Churchstanton, a small village on the Blackdown Hills surrounded by rolling countryside and protected nature reserves, was home to RAF Culmhead during the Second World War due to the vast open countryside that was available to build on. Originally named RAF Church Stanton, it began operations in 1941, with three tarmac runways and a number of hangars being built. Over the next two years Polish and Czech squadrons occupied the airfield and in 1943 the base was renamed RAF Culmhead, to avoid radio confusion with RAF Church Fenton in Yorkshire.

One of the five sets of aircraft fighter pens at RAF Culmhead near Churchstanton.

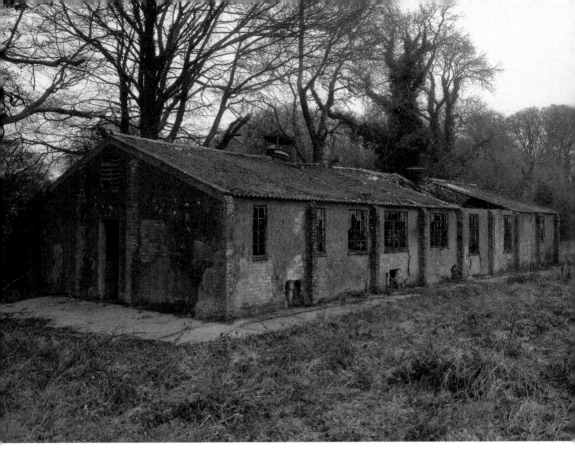

Above: Although in a dilapidated state, a flight office building is still standing.

Below: A huge blister hangar now used for hay storage.

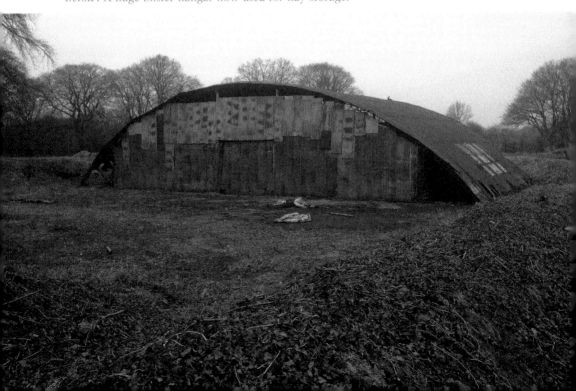

Aircraft continued to participate in operations for the remainder of the war, with No. 131 squadron flying their Spitfire's from Culmhead to Normandy on day one of the D-Day landings. In July 1944, RAF Culmhead became the first base within the Allies to have jet-powered aircraft on site, with arrival of two Gloster Meteor Mk I's. After 1945, the airfield was used for glider and aircraft maintenance training until it was closed in 1946. Today, part of the site is used as an industrial estate, but quite a lot of the original buildings remain dotted about in derelict condition. The control tower, hangars and fighter pens, as well as a myriad of pillboxes and other buildings, are easily accessible on the site, and with information boards up explaining the significance of the site, all you need is your wellies and coat!

14. Cleeve Abbey

The 800-year-old Grade I listed medieval abbey in the village of Washford is one of the best-preserved monastic sites in Britain. Founded as a house for monks in the twelfth century, it was later closed in 1536 by Henry VIII as part of the Dissolution of the Monasteries, and the site was then turned into a rather grand country estate and later into a farm. Built in a valley surrounded by the west Somerset countryside, the peace and tranquillity gives you an idea of why the abbey was built here. As

The medieval monastery of Cleeve Abbey. (Courtesy of Steve Bittinger CC BY 2.0)

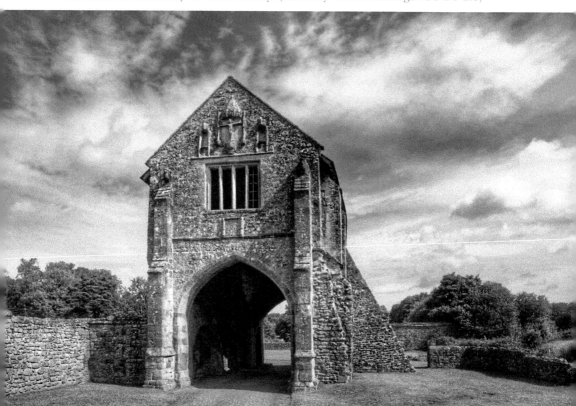

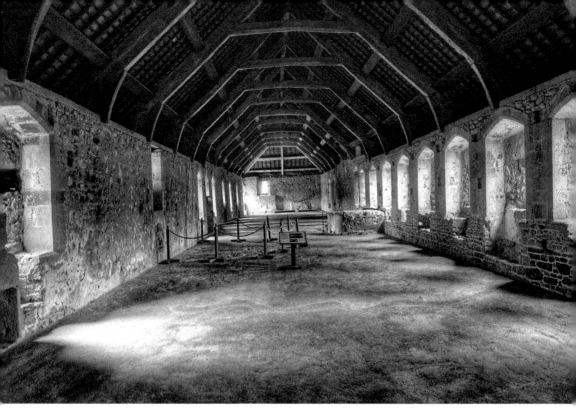

Above: Inside the dormitory. (Courtesy of Steve Bittinger CC BY 2.0)

Below: There are a number of detailed tiles on view throughout the site. (Courtesy of Steve Bittinger CC BY 2.0)

you enter through the impressive gatehouse you get a sense of the size of place and a feel of what it would have been like hundreds of years ago. The cloister, refectory, dormitory and chapter house all have their own story to tell, with wonderful architecture on display through various carvings and the impressive heraldic tiled floors. Although the church was destroyed during the dissolution, Cleeve Abby still retains its spiritual atmosphere, which can be absorbed further by having a leisurely picnic within the grounds while surrounded by the beautiful Somerset countryside.

15. Clevedon

Located in North Somerset just a half an hour from Bristol, Clevedon may seem like an unlikely gem but its legacy as a prominent Victorian-era seaside resort means there are a few treasures waiting to be found. Its proximity to Bristol meant that the pebbled beach and low rocky cliffs became popular during the Victorian craze of bathing in the sea, which saw saltwater baths constructed on the waterfront as a result. Although these have now gone, the bandstand and pier, opened in 1869 and one of the earliest surviving examples of a Victorian pier, remain in situ. At over 300 metres long, the pier is managed by the Clevedon Pier Preservation Society, who saved it from being demolished in the 1970s. Sir John Betjeman described Clevedon

Clevedon Pier at sunset. (Courtesy of Matt Neale CC BY 2.0)

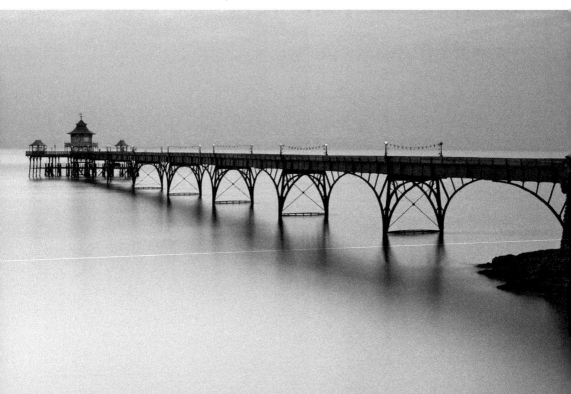

as 'the most beautiful pier in England' and it is now a Grade I listed building. As well as the pier, the clock tower, built to commemorate Queen Victoria's Jubilee in 1898, stands proud in the town. Clevedon Court, a fourteenth-century manor, is now run by the National Trust and the Grade II listed Walton Castle sits on top of a hill to the north of the town, although it is now privately owned. Finally, 'Poet's Walk' is a popular coastal footpath along the southern end of the town, which is said to have inspired poets such as Alfred Tennyson and Samuel Taylor Coleridge, and with views as far as Wales on a good day, it is easy to see why.

16. Donyatt

Between Ilminster and Chard lies the small village of Donyatt and its now idle single-platform railway station. The station was used as an inspection point during the Second World War to stop and check any trains using the lines between Chard and Ilminster, as well as seeing a large number of evacuee children disembark on its platforms as they escaped the large industrial centres being targeted in the Blitz. These days, Donyatt is a walkers' and cyclists' haven, with the old disused railway line now part of the National Cycle Network, where it is possible to wander leisurely for hours surrounded by nothing but fresh air and fields full of wildlife.

The platform at Donyatt Halt.

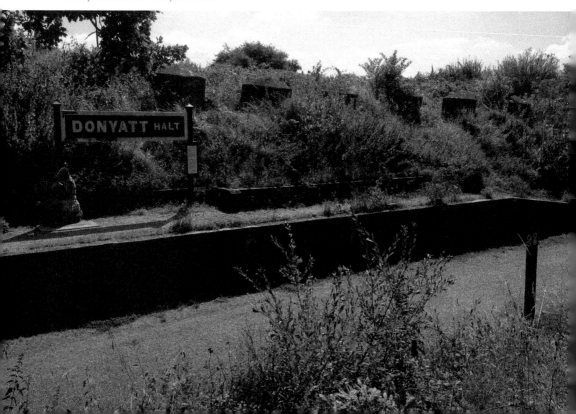

Remnants of the Second World War, such as this roadblock, can be found all around the now-disused platform.

17. Dunster Castle

One of the most splendid sights in the county, Dunster Castle pokes out of the treeline on the top of a steep hill on the outskirts of Exmoor. In the aftermath of the Norman Conquest of 1066, William the Conqueror's tenant in chief, William I de Moyon, became the Sheriff of Somerset and built Dunster Castle by the time the Domesday Book was written in 1086. Originally built of wood, a stone keep was soon built along with towers and many buildings as the castle acted a point of power for the de Moyon family for the next 400 years. It is certainly a castle with history. During the English Civil War in the 1640s, the castle switched hands between the Royalists and Parliamentarians a number of times, with Robert Blake leading a Parliamentarian siege of Dunster, staying in control for the next four years before partially destroying some parts of the castle. In the centuries that followed, the upkeep of the castle proved to be very expensive, and it saw little by way of military action as it became more of a grand home, which is now run by the National Trust. Today, the Dunster estate is in fine condition. Approaching

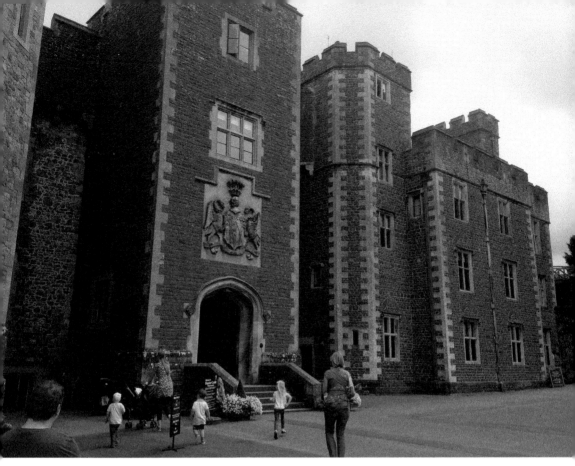

Above: The grand entrance to the castle.

Below: The imposing Dunster Castle. (Courtesy of Alison Day CC BY-ND 2.0)

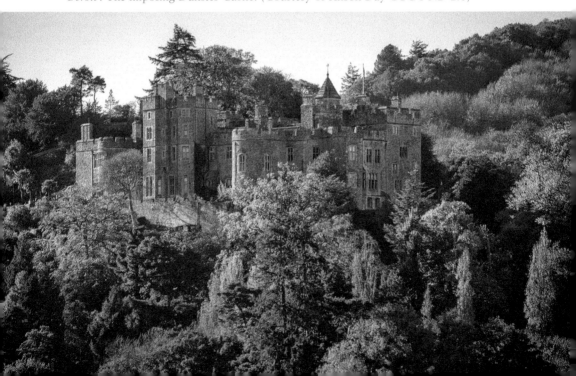

the castle up the cobbled path from the town, you get a sense of how imposing the place would have been and the approach to the entrance sees the walls tower ominously over you. However, once inside you are greeted with a lavish house with all the home comforts anyone could need. From the huge library with more books than you could ever read, the impressive 'Grand Staircase' and the billiard room, not to mention the countless other rooms, it really is a grand residence. One of the best features is the stunning views across the Bristol Channel you can get from the conservatory and these are replicated from the majority of the windows you look out of and also when you go outside. It is possible to spend hours in the grounds of the castle, and the gardens have a whole range of plants and vegetation cared for in the four different microclimates. There is also an unground reservoir beneath the site of the original keep as well as the rather eerie crypt. For those wishing to explore the estate, more wildlife can be found in the vast unspoilt parkland where the children can have a wonderful time on the outdoor trail or dipping their toes in the nearby stream. With bridges, picnic areas and even a working watermill where you can have a go at grinding wheat into flour, this is one gem you can visit time and again and always find something new.

18. Exmoor Heritage Coast

Trying to narrow down the number of picturesque and idyllic harbours and viewpoints in west Somerset to just one or two for inclusion in this book proved to be an impossible task until I decided to wrap them all up under the one heading of the Exmoor Heritage Coast! In doing so, there is something for everyone along this 30-mile stretch of coast from Minehead to Combe Martin (which sits just in North Devon). Of course, as one of the area's largest towns, Minehead offers a range of shops and eateries for anyone visiting its large beach or famed Butlins resort for some traditional seaside fun, as well as being the home to the country's longest steam railway – the West Somerset Railway. However, this is just the beginning of an area that you can easily find something new to do every time you visit!

For walkers, the 630-mile South West Coast Path, the longest National Trail in the country, begins here and winds its way through little villages and around headlands that see the highest tides in all of Europe. Along the route there is an abundance of wildlife to enjoy, both in and out of the water, and there are plenty of hidden coves and secluded beaches to stumble upon, such as the rocky Heddon Valley. Coastal villages offer the opportunity to stop, rest and enjoy wonderful food, with Blue Anchor, Lynmouth, Bossington and Porlock Weir providing enough fun and entertainment for day trips in their own right with good food, beaches and rock pools to explore. At the most westerly edge of the Exmoor Heritage Coast lies the village of Combe Martin in Devon, where you will find the highest cliffs in the country at 'Great Hangman Point'.

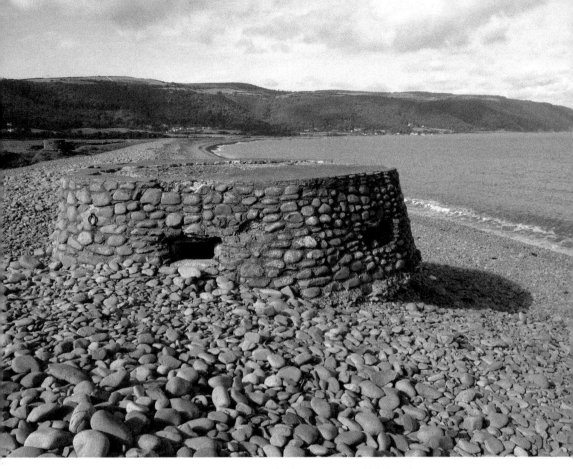

Above: A Second World War pillbox overlooks the vast pebble beach at Bossington.

Below: Porlock Weir is a lovely stop along the Exmoor Heritage Coast. (Courtesy of Ed Webster CC BY 2.0)

The delightfully named Blue Anchor. (Courtesy of Sarunas Mikalnauskas CC BY-ND 2.0)

19. Exmoor National Park

The unspoilt beauty of the 267 square miles of Exmoor National Park means that it is possible to really get away from it all – and everyone. The variety of landscapes and vistas can be breathtaking, from cliffs plunging into the Bristol Channel, miles and miles of remote moorland and vast woodland areas, anyone who enjoys the outdoors will return time and again. As you explore Exmoor it is not uncommon to spot red deer frolicking or see herds of Exmoor Ponies roaming around and grazing

The wilderness of Exmoor. (Courtesy of Kerry Garratt CC BY-SA 2.0)

Above: Ponies are just some of the animals found living on Exmoor. (Courtesy of shrinkin' violet CC BY 2.0)

Below: View of the 50-metre-long Tarr Steps. (Courtesy of Michael Clarke CC BY-SA 2.0)

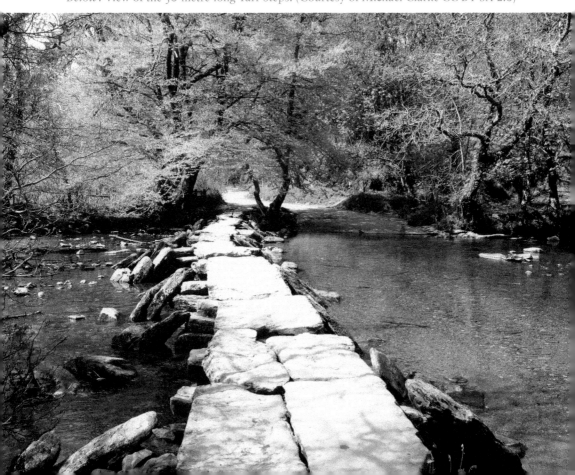

on the pasture. Otters can be found in the streams while butterflies and bats can be seen by those with a keen eye. There are prehistoric standing stones, burial mounds and evidence of hut circles, which demonstrate how humans have been on the site for thousands of years. The Romans mined Exmoor's iron deposits and, more recently, there are the remains of what was the Minehead Armoured Fighting Vehicle Range on North Hill. Built in 1942, it was used exclusively by the US Army in the build up to D-Day as their tank crews honed their skills, and the concrete footprints of buildings, along with the control room of one of the first radar stations, can be found. There are many small settlements and villages just waiting to be discovered as well as numerous picturesque settings for picnics. Watersmeet has a delightful waterfall just waiting to be splashed about in, as well as a National Trust tea shop; Robber's Bridge, which takes its name from the fact that much of the area was dangerous bandit territory in days gone by; and Tarr steps, a seventeen-span clapper bridge that is over 50 metres in length. For the most part, though, it is the sheer size and scale of Exmoor that leaves its mark, with the feeling of peace and being at one with nature, which has inspired writers, artists and poets for many years.

20. Farleigh Hungerford Castle

Right on the border with Wiltshire sat on a low spur overlooking the River Frome is the vast remains of Farleigh Hungerford Castle. The building of what is now the inner court on the site of a manor house was started in 1377 by Sir Thomas Hungerford, who was the first person to hold the office of Speaker of the House of Commons. His son Sir Walter Hungerford, who fought at the Battle of Agincourt, extended the castle by constructing an outer court between 1430 and 1445 and the footprint of the bastion, along with a number of buildings that are still standing, are an exciting visit. During the English Civil War, the Hungerford family declared themselves to be Parliamentarians only to see the castle fall into the hands of the Royalists in 1643. It was retaken by Parliament right at the end of the war in 1645, which meant the castle avoided any slighting – the partial or complete construction of a fortification making it unusable as a fortress. The castle left the Hungerford family in 1686 and by 1730 it was in a state of disrepair, with much of it being broken up for salvage, and this is what we see today. As you walk up towards the gatehouse the scale of the castle becomes apparent as you can see nothing but walls stretching out in front of you. Once inside there are a mixture of well-maintained buildings and the footprints of structures that no longer exist. Two towers dominate the skyline, along with the priest's house and chapel. Saint Leonard's Chapel, with its wall paintings, stained-glass windows and carved family tombs of the Hungerford's, is still used for local events, while there are archaeologically important coffins made of lead in the crypt. The priest's house contains images of the castle from different periods while the grounds inside the battlements are perfect for a picnic, allowing you to contemplate what the castle would have been like during its heyday, before wandering around again imagining.

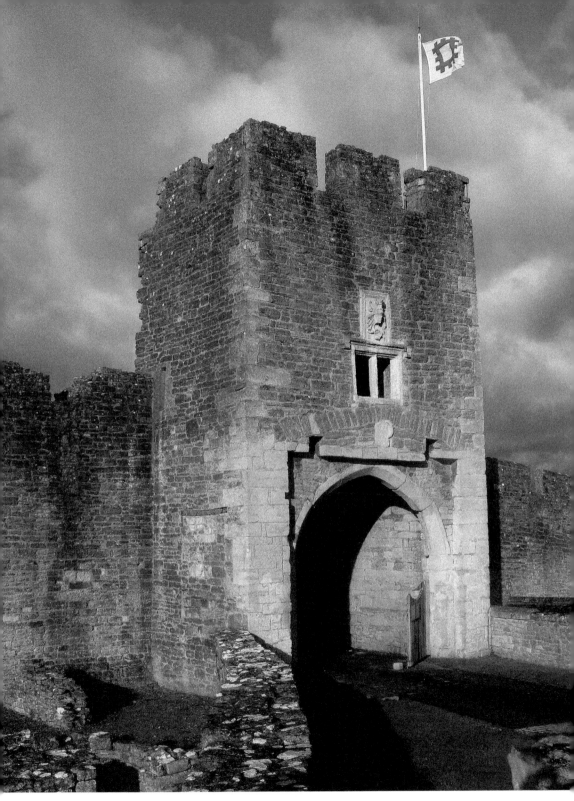

The eastern gatehouse of Farleigh Hungerford Castle. (Courtesy of Nick Sarebi CC BY 2.0)

View across the outer court, with St Leonard's Chapel on the right. (Courtesy of Nick Sarebi CC BY 2.0)

21. Fleet Air Arm Museum

The Fleet Air Arm Museum is sure to get the pulses of every young, and old, child racing! Devoted to the history of British naval aviation, it has one of the largest collections of military and civilian aircraft, with over ninety on display, as well as some 30,000 artefacts and 2 million records spread across four exhibition halls. It is a vast museum. What makes it all the more impressive is that it is located at the edge of RNAS Yeovilton, Europe's largest operational naval air station, meaning there are numerous opportunities to see aircraft take off and land. The first hall sets the scene with the history of aviation, containing some flimsy-looking fabric-covered wooden planes that really underline how brave the early pilots must have been! There are a range of helicopters here, too, with a look at the important role they play in search and rescue missions as well as access to the

archives department. Hall two focuses primarily on the Second World War with British and American planes on show from the Pacific theatre and the Battle of the Atlantic. There is an interesting side room with an exhibit on kamikaze pilots as well as access to an indoor airfield viewing area. Hall three boasts the innovative 'Aircraft Carrier Experience' where once aboard the replica flight deck of HMS *Ark Royal*, complete with ten different aircraft and huge projection screens, you get taken to the very heart of the action – although for some younger children the noise may be quite daunting! The forth hall looks at the Falklands conflict, the role of the massive Sea King helicopters, and perhaps the most famous civilian aircraft in the world – the Concorde. The museum is home to 'Concorde 002', the first British-made Concorde, which was used as a test plane for seven years in the early 1970s, and there is something special about this aircraft that grabs people's attention to this day – my three-year-old son being testament to that by exploring the inside of the aircraft again and again! Being able to see these incredible machines up close is an amazing and unforgettable experience. With a shop for the essential keepsake, a spacious café and a lovely children's play area outside, the Fleet Air Arm Museum is a wonderful place to visit rain or shine, made all the better that with your ticket, you are able to visit as many times as you like within a year.

Hall four of the Fleet Air Arm Museum, complete with Concorde.

Aircraft from all eras are sure to capture everyone's imagination.

22. Fyne Court

To the north of Taunton near the small village of Broomfield you will find the National Trust-owned Fyne Court. Once a large country residence belonging to the Crosse family, and pioneering nineteenth-century electrician Andrew Crosse, it is now a nature reserve. Free to enter, the buildings of Fyne Court now provide members of the public with a visitor centre, café and educational room for school groups. Surrounding these buildings, as the reason for visiting, is a large country estate of woodland, ponds, steams and meadows. There is a range of trails and walks to follow across the 65-acre estate, with varying degrees of difficulty. Within the grounds there is also a folly with two small towers, as well as a boathouse, not to mention plenty of wildlife to explore and fresh air to inhale. Fyne Court gives you a wonderful chance to get away from it all in the glorious Somerset countryside.

Above: The shop and café at Fyne Court. (Courtesy of Rose and Trev Clough CC BY-SA 2.0)

Below: There are plenty of woodland trails and streams to explore.

23. Glastonbury Abbey

Myths, legends and ruins, Glastonbury Abbey has them all. Located right in the middle of the town itself, the abbey is a place of pilgrimage for many and more than just a set of stone relics. Nestled in amongst the modern-day buildings of Glastonbury, it is hard not to be impressed with the grandeur of what remains of the site and the grounds in which they stand as you head up the path to the abbey gatehouse. With some evidence that the site was used during the Roman and Saxon eras, this Benedictine monastery was officially founded in the seventh century. While the foundations of the west end of the nave date to this time, there is a medieval Christian legend that claims Joseph of Arimathea founded the abbey as far back as the first century. The legend says he thrust his staff into the ground, where upon it took root, leafed out and blossomed as the 'Glastonbury thorn'. Unusually flowering twice a year, the original Glastonbury thorn was cut down and burned during the English Civil War by the Roundheads as a relic of superstition. In 1086 when the Domesday Book was commissioned, Glastonbury Abbey was the richest in the country. However, its fortunes significantly dwindled over the next hundred years with pilgrim visits, a great source of income, falling significantly. Adding to the woes of the monastery, much of the abbey was destroyed in a fire in 1184. Rebuilding started almost immediately and with it, came another legend: the discovery of King Arthur and Queen Guinevere's tomb. The majority of historians today cast significant doubt on the authenticity of this, suggesting it more of a publicity stunt to raise money for the repair of the abbey and place Glastonbury back at centre stage on the pilgrimage trail. The legend of King Arthur has been linked with the abbey ever since, along with the possibility that the mystical land of Avalon lay within Somerset, and whatever you believe, visiting the site of King Arthurs 'supposed' resting place is a powerful experience. By the fourteenth century it was back to being one of the richest and most powerful monasteries in the country and remained so until the Dissolution of the Monasteries by Henry VIII. Abbot Richard Whiting was executed on Glastonbury Tor and the abbey was stripped of its valuables, with all the lead and much of the stone being taken and reused for other constructions, leaving the Abbot's Kitchen as the only building to remain intact. Described as 'one of the best preserved medieval kitchens in Europe', this octagonal kitchen has four massive fireplaces and has a vast array of replica artefacts on display, giving you a real sense of what it was like all those years ago. Over 100,000 visitors a year look in awe at the size of the ruins of the great church, each of them trying to imagine what it would have looked in its complete form. At over 60 metres long and 14 metres wide it is absolutely huge. The Lady Chapel, with its two levels, gives a glimpse of what it would have been like inside this vast building, and the stone footprints of other buildings on site add the understanding of just how important Glastonbury Abbey was. As well as the ruins, there is an informative visitor centre that offers school children in particular great opportunities to extend their learning, including dressing up as a monk. Beyond the remnants of the abbey there are ponds, wildlife and plenty of quiet space to contemplate within the 36 acres of parkland that you are able to enjoy. The history, legends and sheer size of Glastonbury Abbey make this one of Somerset's best gems!

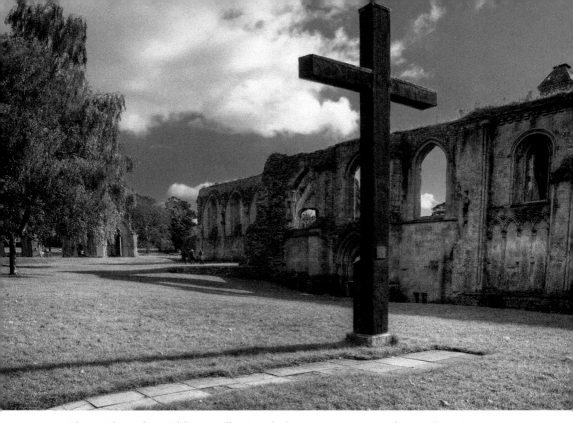

Above: Glastonbury Abbey is still a site of pilgrimage. (Courtesy of Steve Slater CC BY 2.0)

Below: The extensive ruins of the abbey. (Courtesy of John Connell CC BY 2.0)

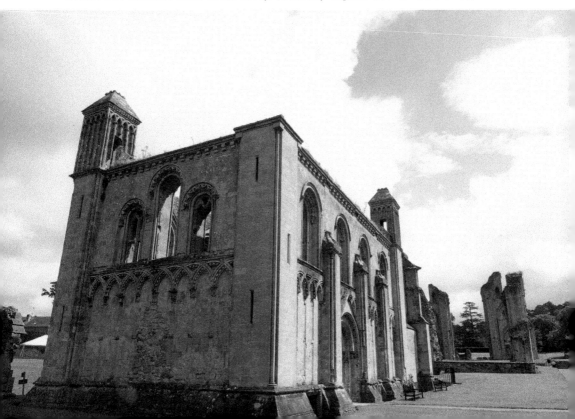

There's lots to explore within the abbey grounds. (Courtesy of tpholland CC BY 2.0)

24. Glastonbury Festival

As a teenager is there anything more iconic than seeing your favourite band playing at Glastonbury?! For many in the music world just playing here is the sign that 'you've made it' and headlining is the absolute pinnacle of achievement. Held just outside Glastonbury in the village of Pilton, the Glastonbury Festival has around 175,000 people attend the five-day event that sees not only music, but dance, theatre, circus, cabaret and other arts perform. The first festival at Worthy Farm took place in 1970 and since then a whole host of world-famous bands and solo acts from all genres of music have performed, including the Rolling Stones, David Bowie, Oasis, Paul McCartney, The Who and Coldplay, who have been the headline act a record-breaking four times. The festival is

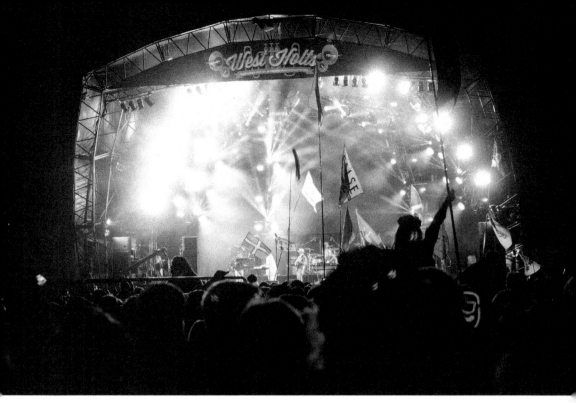

Above: Playing at Glastonbury is arguably the pinnacle of any band's career. (Courtesy of Rachel Docherty CC BY 2.0)

Below: Glastonbury park by night. (Courtesy of Rachel Docherty CC BY 2.0)

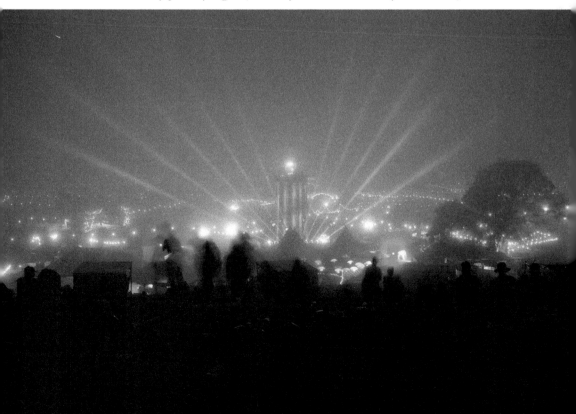

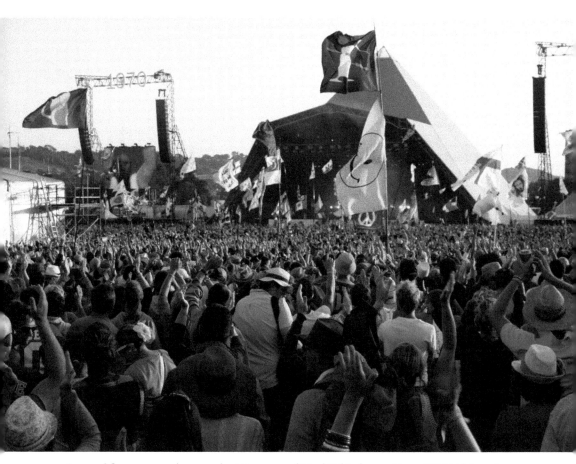

A sea of flags among the crowds. (Courtesy of Neal Whitehouse Piper CC BY-SA 2.0)

mainly run by volunteers and a significant amount of the profits each year go to international and local charities, with Oxfam, Greenpeace and WaterAid being the main beneficiaries. Of course, 'mud' is a word that is synonymous with the Glastonbury Festival, with the great British weather often turning the fields full of tents into mini rivers. For those attending all week and camping out, the poor weather has never dampened spirits, and in a lot of cases it is seen as part of the Glastonbury experience. For those not quite willing to spend a week in a tent, day tickets are available and provide a wonderful opportunity for people to experience the festival. However, in recent years all tickets have been sold within a matter of hours of being released. The lights, the sounds and the sea of flags all contribute to something quite special, where just being there is, in some respects, more important than being able to see your favourite acts up close. Taking a step back to consider the Glastonbury Festival, it can be difficult to appreciate that something so well known all around the world takes place right here on our doorstep in Somerset.

25. Glastonbury Tor

The town of Glastonbury is known across the world for many different reasons, one of which is its tor. Situated within walking distance from the abbey, Glastonbury Tor is a must see for anyone visiting the town; in fact it's impossible not to! Rising up over 500 feet from the Somerset Levels, it is clearly visible for miles around and has been mentioned in Celtic mythology, particularly those legends that include King Arthur. There is evidence of buildings being present at the summit during the Saxon period and atop the tor now sits the roofless St Michael's Tower. This is all that remains of a fourteenth-century stone church that was demolished by Henry VIII during the Dissolution of the Monasteries and also the place of execution of the last abbot of Glastonbury Abbey, Richard Whiting. This church was built in the place of an earlier wooden church that was destroyed by an earthquake in 1275. With two pathways up, one significantly steeper than the other, it is a brisk walk up to the top that catches even the seasoned walker out of breath as their pace quickens when in sight of the summit. It is all worth it though for the view, which on a clear day stretches for miles around in every direction. Young and old alike find it awe-inspiring, taking time to work out the towns and villages that lie beneath them, before taking the obligatory selfie in front of the tower prior to making the much shorter trip back down. Maintained by the National Trust, the tor is freely accessible all year round.

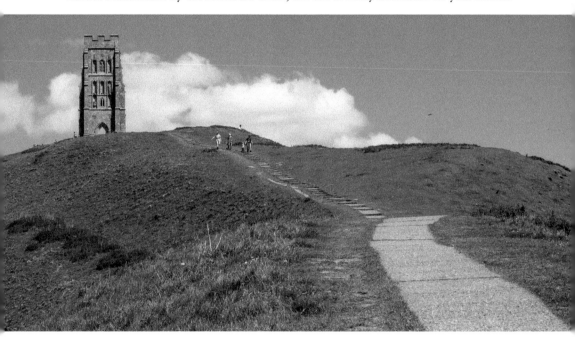

The idyllic Glastonbury Tor. (Courtesy of Ed Webster CC BY 2.0)

26. Haynes International Motor Museum

If you like cars then the Haynes International Motor Museum is certainly for you. There are over 400 cars and bikes in what is the UK's largest single collection of automobiles and the enthusiast will be able to spend hours marvelling over these vehicles in nineteen exhibitions. The vintage cars on display from the dawn of motoring in the Victorian age show the humble beginnings that this now indispensable mode of transport came from, in stark contrast to the supercars on display, such as the Jaguar XJ220. With a dedicated selection of Ferraris, a range of Rolls Royces and Bentleys and hundreds of other cars from across the world there is bound to be everyone's dream car on display. If one section encapsulates the developments of the last hundred years, it has to be the Hall of Motorsport. Here you can see the fastest cars of their time and note how they become more aerodynamic and finely created,

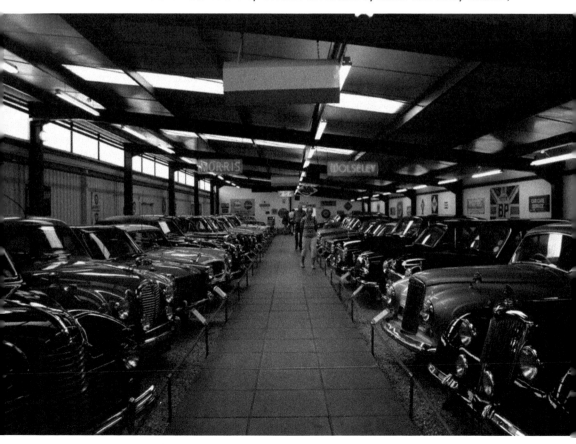

If you like your classic cars, this is the place to go. (Courtesy of Glen Bowman CC BY 2.0)

from the Allard V8 that came fifth in the 1947 Alpine Rally right up to the 2010 Red Bull 6, which Australian Formula One driver Mark Webber drove to four Grand Prix victories that year. What is impressive about this museum is the way in which all ages are catered for, with a dedicated indoor soft play area, outdoor mini road system and construction zone for the youngest; themed play areas, interactive stations and trails to follow; and karting available on the full test circuit opposite the museum for those wishing to race on the same track that Formula 1 2009 World Champion Jensen Button practiced on many years ago.

27. Hestercombe House

The country house at Hestercombe on the Quantock Hills has an interesting and varied history. The estate was originally created and owned by Glastonbury Abbey in the eleventh century before it was passed to the La Ware family in the

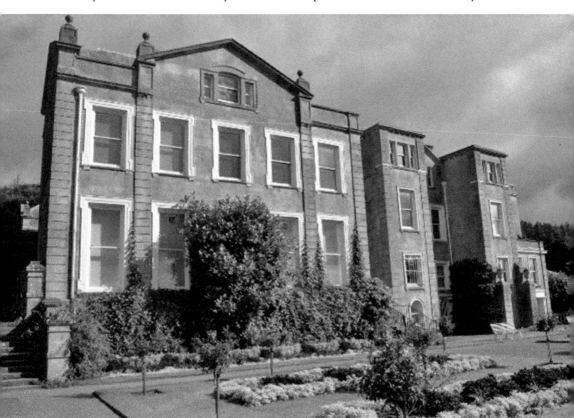

Hestercombe House. (Courtesy of Ashley Dace CC BY-SA 2.0)

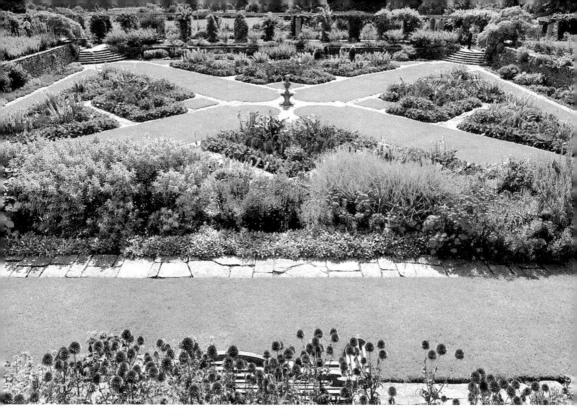

An incredible array of flowers in the beautiful gardens. (Courtesy of xlibber CC BY 2.0)

fourteenth century, who constructed the house that is still standing today. In the eighteenth century, a Georgian landscape garden was designed and established with ponds, a grand cascade, a Gothic alcove, a Tuscan-style temple and a folly mausoleum, all of which you can still find today hidden within the 100 acres of land. In 1873 the Portman family purchased the manor and between 1904 and 1906 the Honourable E. W. B. Portman had the great horticulturist Gertrude Jekyll and renowned architect Sir Edwin Lutyens design an Edwardian garden. These gardens make up nearly half of the total estate and are wonderful to explore. With the beautiful south-facing gardens overlooking the Blackdown Hills, the different gardens at Hestercombe each have their own atmosphere and different range of plants. The outbreak of the Second World War saw the grounds and house used initially by the British Army as the headquarters to command the defence of the South West. When the threat of invasion abated, the American Engineer Regiment moved in, with General Eisenhower visiting in 1944. After the D-Day landings the site became an American Hospital Centre, and the remains of one of the barrack blocks can be found on the grounds, which is dedicated to the memory of all the men and women who served here. There is, however, one more interesting piece of history before Hestercombe became the attraction it is today. Between 1953 and 2012 the house itself was used as the Emergency Call Centre for the Somerset area of the Devon and Somerset Fire and Rescue Service, before being restored to its current state. Whether its paddling in the stream, walking through the gardens, spotting wildlife or following a family trail, there is a lot at Hestercombe House to keep everyone busy.

28. Kilve

The small village of Kilve was listed in the Domesday Book of 1086 as 'Clive', meaning 'cliff', and chances are if you are heading to Kilve today you are heading to the stunning wave-cut beach. Of course, you might be heading to Kilve Court, which is a residential and outdoor learning centre run by Somerset County Council, where school groups are offered the chance to participate in academic enrichment courses as well as adventurous activity courses, which make the most of the wonderful surroundings it finds itself on in the Quantock Hills Area of Outstanding Natural Beauty. Kilve beach is a designated SSSI (Site of Special Scientific Interest) thanks to the cliffs, which are formed by oil-rich layers of rock, which often contain fossils. The walk down to the beach from the car park is fairly brief and on the way you pass the remains of an oil retort, built to convert shale to oil in the 1920s, but this was short-lived. As you approach the beach you are greeted by a large grassy area that is perfect for picnics. The shoreline itself is rocky and you are certain to find plenty of rockpools worth exploring. Keeping your footing is important, particularly when heading further out and around the headlands, where you can be met with strong gusts of wind. The way in which the wind and waves have cut the rock is mesmerising, and young and old alike will study the different layers of rock that

The windswept beach at Kilve.

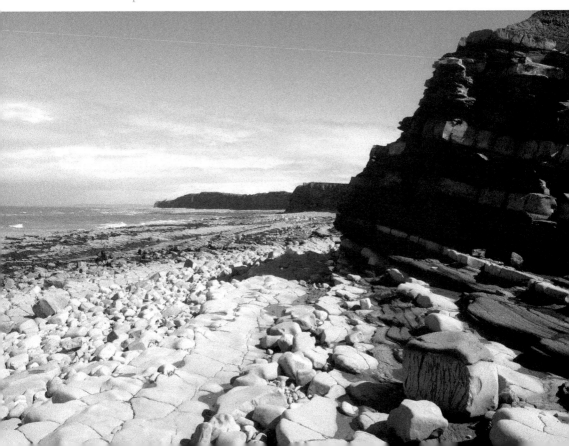

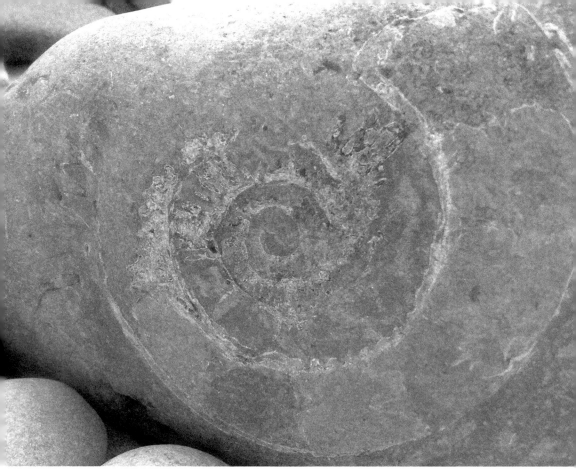

There are an abundance of fossils just waiting to be found. (Courtesy of Andy Bateman CC BY 2.0)

have been exposed. Then of course, there are the fossils. The dinosaur hunter in all of us has the chance to explore the miles and miles of coastline in the search for the remnants of these creatures. The local museum has the skull of Ichthyosaur found here on display, and while we all dream of being the first person to discover a complete skeleton of a new species of dinosaur, it is easily possible to find an ammonite fossil somewhere on the beach, sometimes whiling away hours in doing so.

29. Mells Village

Asked to think of the quintessential English village and you might well be talking about Mells, a small village near Frome that has all the old-world charm you could imagine, along with some really interesting historical footnotes. First and foremost, Mells is a beautiful little place that almost seems to be stuck in time. With delightful architecture, narrow ancient streets and quirky buildings, Mells is a place you can

happily spend hours wandering around before stopping in the village café or pub. Most prominent in the village's history are the Horner and Asquith families, who have made the village what it is today. In 1543, four years after the Dissolution of the Monasteries, Thomas Horner bought all of Glastonbury's lands in Mells, including the manor house, and it remained in the family for years to come. In 1644 Charles I stayed at Mells and the Horner family has seen politicians and statesmen within its ranks over the years. At the end of the nineteenth century, Sir John Horner commissioned works from the world-renowned architect Sir Edwin Lutyens right across the village, and these are a huge draw for anyone visiting today. Lutyens added features to the manor house and the war memorial, which is a Grade II listed building. This memorial was unveiled by Brigadier-General Arthur Asquith, whose brother Raymond was killed during the First World War. Raymond was the eldest son of Prime Minister H. H. Asquith and married Katherine Horner, the daughter of Sir John Horner, in 1907, with Mells becoming the family home. Lutyens also redesigned and rebuilt the other large house in the village, Mells Park, in 1923. If the Horner name sounds vaguely familiar, that is because of the nursery rhyme 'Little Jack Horner'. In the nineteenth century a rumour began that the rhyme is actually about Thomas Horner, who was steward to Richard Whiting, the last abbot of Glastonbury. The story goes that prior to the Dissolution of the Monasteries, Whiting sent Horner to London a Christmas pie for the king, which had the deeds to a dozen manors hidden within it as a gift in an effort to convince him not to nationalise Church lands. During this journey, Horner opened the pie and kept the deeds to Mells Manor for himself. While records show that Horner paid for the title, it is an interesting little anecdote. One final interesting building in Mells is the old village lock-up, which was used for the detention of people in the village, usually for the confinement of drunks. All in all, Mells is a splendid little village with so much history on offer.

The picturesque Mells Village. (Courtesy of Andy Walker CC BY-ND 2.0)

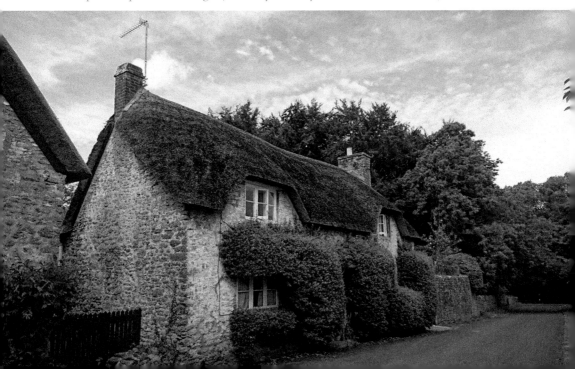

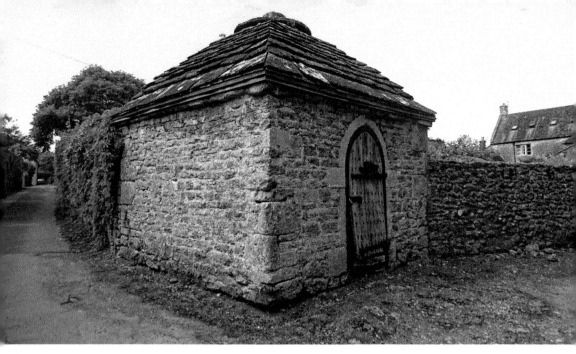

The village lock-up still remains. (Courtesy of Andy Walker CC BY-ND 2.0)

30. Mendip Hills

The Mendip Hills are a designated Area of Outstanding Natural Beauty that cover over 75 square miles between Weston-super-Mare and Frome. The vast limestone hills incorporate Wells, Shepton Mallet, Cheddar, Wookey Hole Caves and, of course, Cheddar Gorge, where the limestone rocks have been eroded away over millions of years leaving a stunning landscape. This is a walkers' paradise with a diverse range of places to explore. Woodland areas provide a rich habitat for wildlife; streams and steeply cut gorges zigzag the land; there are valleys full of beautiful flowers to find; and, of course, vast open windswept and wild plateaus are numerous. There are over 200 scheduled ancient monuments recorded across the Mendips and there is evidence to suggest these hills have been used since Neolithic times, with barrows easy to come by. Unsurprisingly there were many Limestone quarries across the hills, with a few still in operation today, so it is important to heed any warning signs you might come across. During the Second World War, Black Down Hill was used as a bombing decoy site. Codenamed 'Starfish', the aim was to recreate the lights of Bristol and thereby encourage the Luftwaffe to drop its payload on the isolated hills instead of the city. Bunkers were built to house generators that powered the lighting of a 'poorly' blacked-out city. A 'Z-Battery' anti-aircraft battery was established, and with the fear of invasion in 1940, over 1,500 'tumps' (mounds of earth) were created to stop enemy aircraft landing, all of which are still accessible from Tynings Farm. There are many open access footpaths and bridleways all over the Mendips, with the 50-mile Mendip Way linking Weston-super-Mare and Frome and the 36-mile

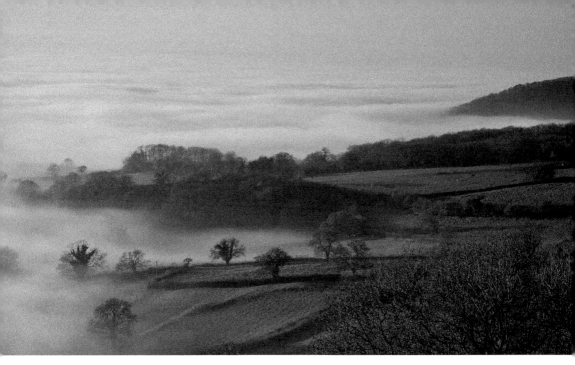

Above: Mist over the Mendip Hills. (Courtesy of Tony Buckley CC BY 2.0)

Below: The remains of a Second World War decoy site.

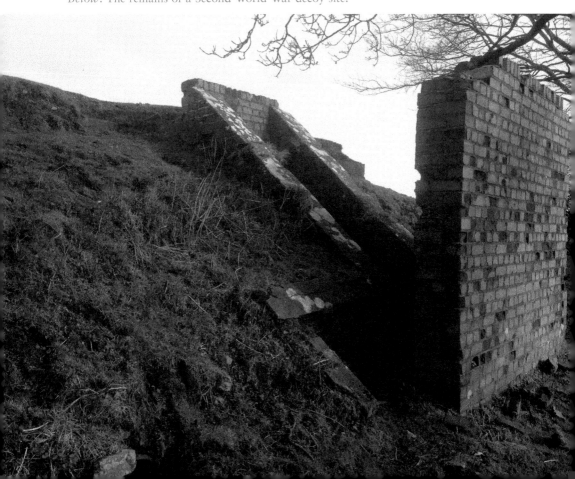

Limestone Link connecting the Mendips to the Cotswolds. With Cheddar Gorge and Wookey Hole offering people the opportunity to go caving and rock climbing, this is an outdoor wilderness worth exploring.

31. Minehead

For many, Minehead is one of the go-to destinations for a traditional seaside holiday and a lot of the town's income was and still is generated by tourists. Much of this is due to the Butlins holiday resort that was opened in the town in 1962, offering families the opportunity of a beach holiday in this country at a reasonable price, with plenty of entertainment. The sixties and seventies saw all the tried and tested Butlins ingredients established at Minehead: a funfair, ballroom, tennis courts, sports fields, arcades of shops, table tennis, snooker, theatre, miniature railway and amusement arcades. One of the main draws of course was the Butlins Redcoats, who ensured that everyone had a super holiday, desperate to return next year. While the types of

Minehead has a vast beach. (Courtesy of Joybot CC BY-SA 2.0)

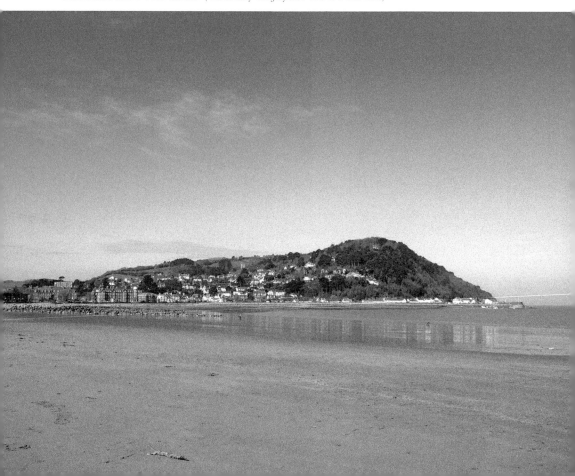

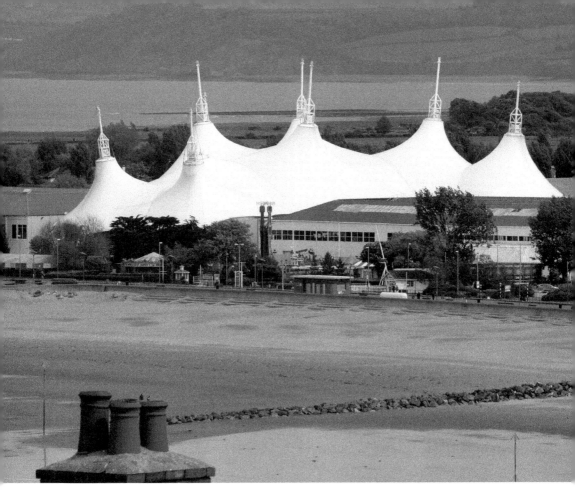

The skyline pavilion at Butlins – a familiar sight for many families. (Courtesy of Ian Sherlock CC BY-SA 2.0)

entertainment may have developed over the years, so too has the resort, with the now distinctive white Skyline Pavilion being constructed in 1999 and is one of the first things you can see when approaching the town. What hasn't changed is the lovely sprawling beach, which remains the main draw of the town given the fact that it is so big and gives everyone their own space to relax and build sandcastles. The promenade, which stretches along the seafront, offers a range of amusement arcades, ice-creams stalls, shops selling knickknacks, as well as cafés and restaurants that cater for everyone's taste.

32. Montacute House

Montacute House is a splendid example of an Elizabethan mansion with some stunning gardens. Located in the village of the same name in south Somerset, the house was built in 1598 for Sir Edward Phelips and remained in his family

until the early twentieth century, before being acquired by the National Trust in 1927. While the name might not be easily recognised, he was the opening prosecutor during the trial of the Gunpowder plotters after their failed attempt to blow up the House of Lords during the state opening of parliament. Clearly a man of stature and wealth, he was at the centre of English political life at the time and needed a home to match his status. Taking three years to complete, the three-storey mansion was probably constructed by William Arnold and set out in an 'E' shape, as was popular at that time. Internally, the house originally had no corridors and the rooms led directly into each other, but over the years new styles came and the house we see today has corridors separating the ground-floor and the first-floor bedrooms. Montacute is certainly visually appealing when viewed across the lawn towards its east front. The size and symmetry of the house draws you closer and then it is possible to see statues carved into niches between the windows on the second floor. Inside, you get a sense of what life would have been like living here, with a great hall, beautiful library and dining hall taking centre stage. On the second floor and spanning the entire 52-metre-width of the house, the Long Gallery is the longest surviving in the country. A common feature in sixteenth- and seventeenth-century houses, the long gallery could have many purposes, and there is a fantastic story of the Phelips children taking their ponies up the stairs to ride in the gallery during inclement weather. Once you have explored the house the well-established gardens are worth wandering around. There are nearly 10 acres of well-manicured formal gardens around the house, and beyond these there are over 250 acres of parkland belonging to the estate. Together, these are Grade I listed and seem to go on endlessly. If you've not been to Montacute House before, but think you may have seen it, you may well be correct. The house, gardens and village have been used as settings in many films and TV programmes, and upon visiting this delightful manor yourself, it will be easy to understand why, as it feels like you are entering a period drama.

The impressive façade of Montacute House. (Courtesy of Andy Walker CC BY-ND 2.0)

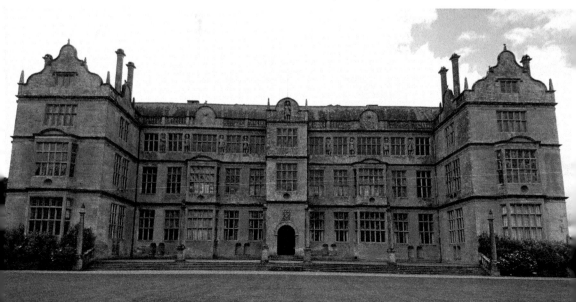

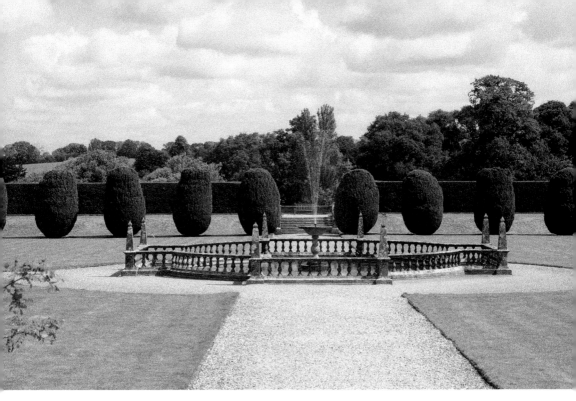

Glorious gardens to explore. (Courtesy of Lil Shepherd CC BY 2.0)

33. Muchelney Abbey

Within the small village of Muchelney on the Somerset Levels are the ruined walls and foundations of a medieval Benedictine abbey. The monks originally established the abbey at some point in the tenth century, and at the time of the Domesday Book it paid a tax of 6,000 eels a year, which were caught from the local rivers and streams. By the twelfth century the abbey was very profitable and the majority of the building work was carried out then. By 1308 they had built the 'Priest's House' on nearby land and this building is still standing today in the village. In the sixteenth century a large abbey church was constructed along with the Abbot's House, but everything was surrendered by the monks in 1538 to Henry VIII as part of the Dissolution of the Monasteries. All the buildings were destroyed, with stone from the site being recycled and reused in many local buildings. Aside from some decorative floor tiles, which were relaid in the nearby Church of St Peter and St Paul, all that remained was the Abbot's House, and this is the stand out feature of a visit today. The site is set within green rolling hills and the stone foundations on the floor give you a tantalising glimpse of what would have been an impressive abbey complex. The abbey building itself was over 50 metres long, with only Glastonbury Abbey being longer in the county, and there are stone footprints of a range of other structures. The Abbot's House is well preserved, with a great chamber inside that has

The ruins of Muchelney Abbey and the modern-day Church of St Peter and St Paul. (Courtesy of Hugh Llewelyn CC BY 2.0)

Below: Inside the church there is a beautiful decorative ceiling. (Courtesy of Paul Bailey Photography CC BY 2.0)

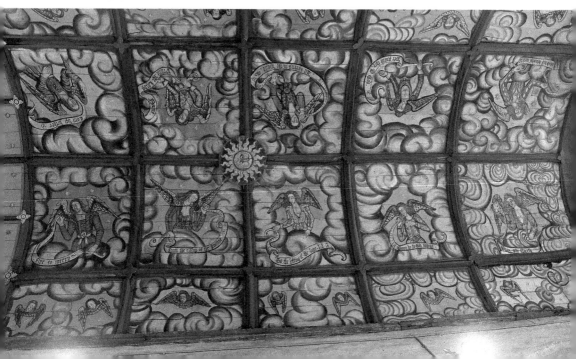

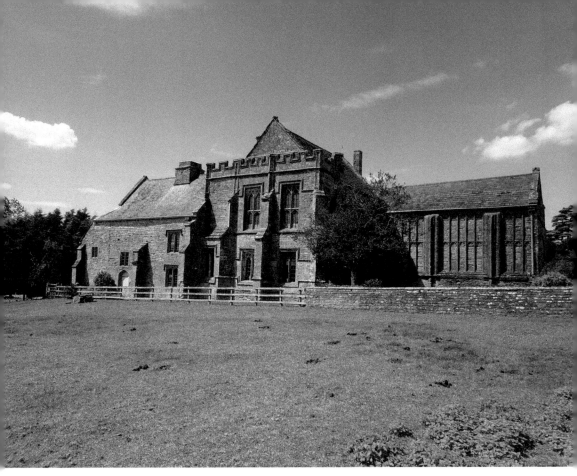

The rather grand Abbot's House. (Courtesy of Hugh Llewelyn CC BY 2.0)

a rather ornate fireplace, a carved wooden settle (seat) and stained glass. There are even wall paintings that are easily visible and show a snapshot of abbey life back in the sixteenth century. The Church of St Peter and St Paul, adjacent to the abbey and overlooking the ruined walls, is also worth visiting for its beautiful painted wooden ceiling.

34. Museum of Somerset

The Museum of Somerset has to be one of the best free museums in the entire West Country, let alone Somerset. Modern, well maintained and with regular events and activities aimed at young and old alike, it provides people with a wonderful chance to engage with the past. Set right in the middle of Taunton, the location itself is full of historical significance, being on the remains of Taunton Castle, which in its day was very important. The Anglo-Saxons originally constructed a defensive building that later became an Augustinian priory, followed in the early twelfth century with the

Bishop's Hall that was then converted into a small castle. By 1138 it had grown into a significant stronghold and the First Barons' Revolt of 1216 was successfully defended against. Over the next century the keep is thought to have grown in size to 20 metres by 30 metres. The son of Simon de Montfort, the man who led a rebellion against Henry III in the Second Barons' War, was held prisoner within its walls for a number of years. As styles changed during the Tudor era so did the castle, with buildings being added and modified until the castle began to lose its defensive significance and took on the role as more of a grand show of power. However, by the English Civil War in the 1600s it had been re-established as a defensive site by the Royalist troops because of its strategic importance on controlling the main road from Bristol to the West Country. By September 1644, Parliamentarian forces under the command of Colonel Sir Robert Pye and Robert Blake surrounded the town and claimed it without any fighting and held it until 1645, in which time Royalist armies had laid siege to the town on no less than three occasions. In September 1644, Royalist troops from around Somerset converged on the Parliamentarian forces in the area and forced them back into the grounds of Taunton Castle, where they blockaded them with the aim of starving Blake and his troops into submission. They held out and by December 1644 a second Parliamentarian force joined them, forcing the Royalist troops to drop the blockade and move away. They returned in March 1645 to find some earthwork defences and small forts in place around the town and fierce fighting took place, forcing the Parliamentarian troops to once again move back to the safety of the castle. The Royalists were unable to break through the perimeter defences of the castle despite repeated attempts, and were themselves forced to retreat from the town when another Parliamentarian army turned up just in time as supplies within the castle dwindled. By May 1645 the Royalists returned with a large army of over 10,000 troops and besieged the town for a third time. Despite their numbers, the Royalist siege was fairly lax and allowed supplies into the town. The Parliamentarian troops inside the town kept the Royalist force at bay for over two months, occupying them when they could have been deployed elsewhere in the country by King Charles. By July, a third Parliamentarian relief force headed to the town, making the Royalists withdraw yet again. It is thought that over half the town was destroyed during this time.

Less than twenty years later, the Royalists got some sort of revenge, with the infamous Judge Jeffreys using the Great Hall at Taunton Castle to conduct his Bloody Assizes. In September 1685 in the aftermath of the failed Monmouth Rebellion, over 500 supporters of James Monmouth were tried, resulting in over 140 being hung, with their remains being displayed in the town – and across the county – as a warning to others. For the next hundred years or so, the castle was used as a prison but fell into a state of disrepair. Thankfully the Member of Parliament for Taunton in 1786, Sir Benjamin Hammet, began restoring the castle and a century later, in 1873, the Somerset Archaeological and Natural History Society purchased the castle and restored the Great Hall. Today, it is the home of the Museum of Somerset and the Somerset Military Museum and contains a large range of artefacts from across the county from many different eras. Most impressive is the collection of medals, memorabilia and uniforms from different military campaigns, with a particular focus, understandably, on the Somerset Light Infantry Regiment and the role they played in various conflicts. Stretching over three levels, with a good gift shop and with a very active education programme that encourages toddlers and school groups to visit, there really is something for everyone.

The Museum of Somerset is housed in the remains of Taunton Castle.

35. Nunney Castle

There can be few places in Somerset that are as picturesque as the ruined moated castle of Nunney. Located in the village of the same name, it was built in 1373 on the site of a manor house by Sir John de la Mare, a local knight, in response to the possibility of a French invasion. It is essentially a three-floor tower keep surrounded by a moat, and the external walls are still standing in much the same condition as when first constructed. With walls over 2 metres thick and rising up to 16 metres in height, it is an impressive structure that once had living quarters, a kitchen, a hall, a chapel and even an armoury. There was a drawbridge across the 3-metre-deep moat, which would have made any potential attack very difficult. Of course, the feared French invasion never happened, and the castle was used as an impressive home, receiving various redesigns over the years, providing those inside with a life of luxury. At the start of the English Civil War in 1642 a Royalist army was garrisoned at Nunney Castle and in 1645 a Parliamentarian army opened fire with cannons in an offensive that breached the castle walls and forced those inside to surrender.

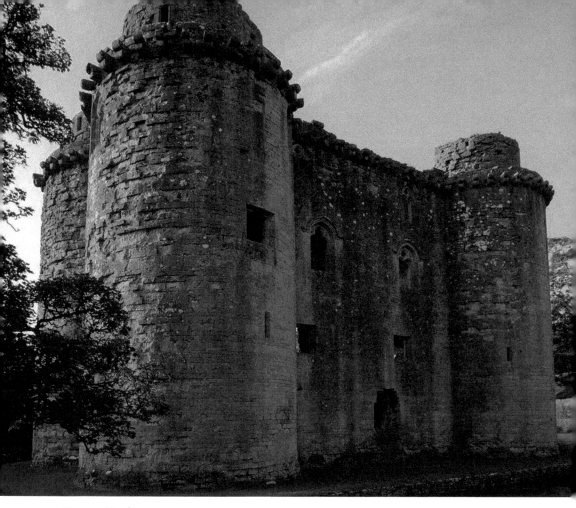

Nunney Castle.

This was the only real military action that Nunney ever saw, with the castle swapping hands numerous times over the next few hundred centuries, before gradually falling into a state of ruin and disrepair, with ivy covering its walls and stone being taken by local people. Today, the ruined shell is maintained by English Heritage, with the site free to visit all year round. There is sadly very little left of the internal rooms, but it is still possible to stand at the very heart of the castle and make out the various floors and rooms, with the four round towers still standing strong.

36. Pawlett Hams

With so much stunning scenery and so many natural parks across the county, it is maybe something of a surprise to have the lesser-known Pawlett Hams on this list. The small village of Pawlett, just to the north of Bridgwater (mentioned in

the Domesday Book), has a 100-hectare wetland nature reserve that occupies the bow of the River Parrot. Designated a Site of Special Scientific Interest, there is a network of ponds, ditches and fields that attracts invertebrates, water vole and a whole host of birds, particularly the Lapwing, to live here. With a free car park and well signposted public footpaths to follow, you can meander across fields with cattle and follow the curve of the river in almost perfect isolation from the 'real world'. On the opposite side of the banks are the newly created WWT (Wildlife and Wetland Trust) Steart Marshes, making this a fantastic place for wildlife of all types. As you approach the car park for the Pawlett Hams it is impossible to miss a huge metal structure and its history is a very interesting addition to the area. This was the site of an RAF research station into anti-barrage balloon warfare during the Second World War, due mainly to the vast expanse of open fields and the lack of people living there. This massive hangar is over 30 metres long and 20 metres high and was constructed so that the balloon, filled with a mixture of hydrogen and air, would not need to be deflated each night, and that repairs and maintenance could easily be carried out. The experimental work continued here until 1944, with the test pilots flying their aircraft into the cables to test the effectiveness of a range of cutters. Although the hangar is on private land and off limits to most, there are associated defensive pillboxes and the partial remains of a navigation beacon on and around the Pawlett Wetland Reserve.

An aerial view of the Pawlett Hams. (Courtesy of Adam Cli CC BY-SA 4.0)

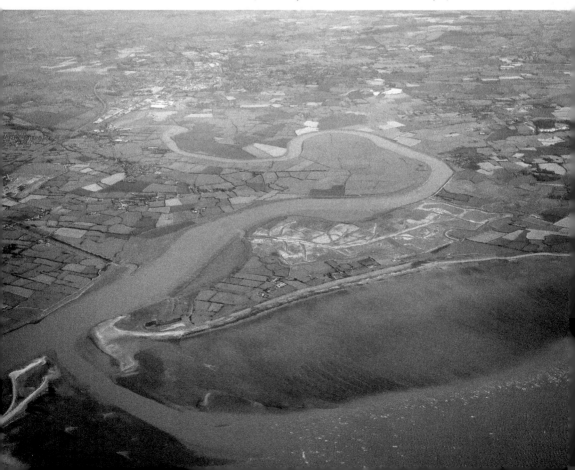

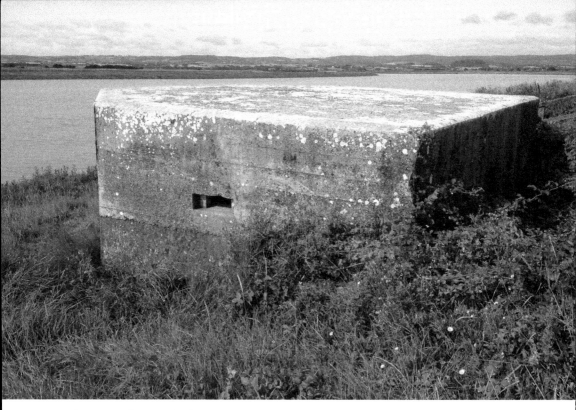

Above: A pillbox on the banks of the River Parrett.

Below: The huge hangar of the RAF research station.

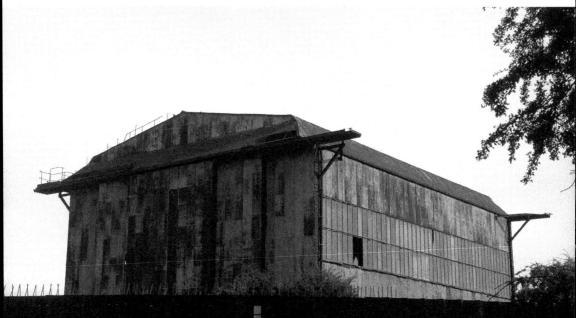

37. Prior Park

Yet another beautiful landscape to explore in Somerset is Prior Park, a house and landscaped gardens on the outskirts of Bath. Escaping the hustle and bustle of the city is something most people aspire to, but being in these tranquil surroundings and yet being so close to home that you can actually see the city of Bath in the distance meant that this was the perfect escape for Ralph Allen, who had it built in 1742. An entrepreneur and philanthropist, Allen bought the local mines that were responsible for quarrying the beautiful honey-coloured Bath stone that most of the city was built with. He tried to supply the stone for buildings in London but after failing with this bid, he set about creating a grand building that would show off the properties of Bath stone as a building material, and Prior Park House was born. Although the original plans had significantly more buildings than were actually built, the resulting structure is still magnificent, standing at nearly 400 metres in length. Designed by John Wood, the symmetrical Grade I listed building has fifteen bays making up the main building, along with its grand Doric columns and two wings on either side, each seventeen bays in length. The house is sadly off limits to the public as it is currently used as the rather grand setting of Prior Park College, a Roman Catholic public school. However, the adjoining 57-acre Prior Park Landscape Garden, which was obtained by the National Trust in 1993, is not. Originally set out in 1100 as part of a deer

Views of Bath from Prior Park. (Courtesy of Karen Roe CC BY 2.0)

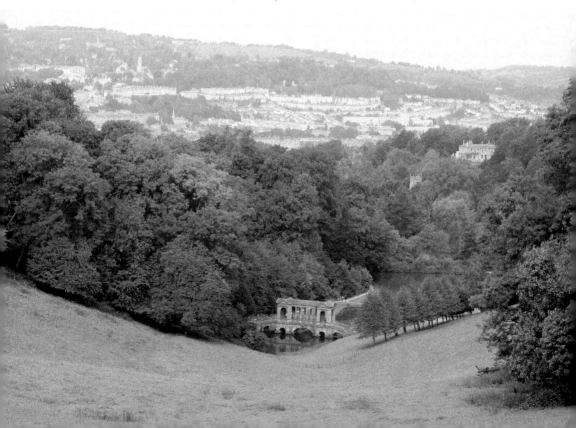

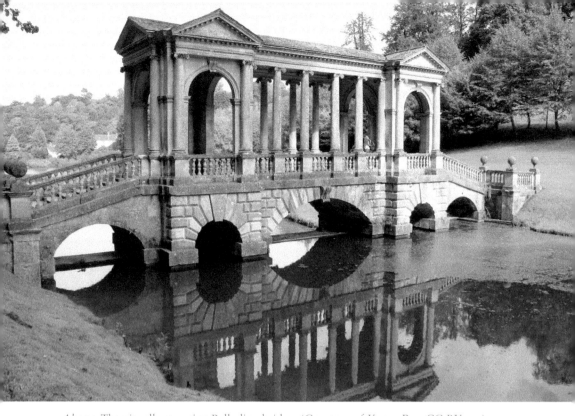

Above: The visually stunning Palladian bridge. (Courtesy of Karen Roe CC BY 2.0)

Below: Look closely and you can find some very old graffiti. (Courtesy of Karen Roe CC BY 2.0)

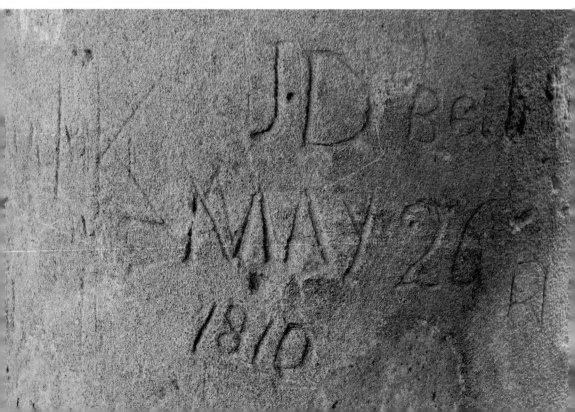

park, nearly 30 acres of landscaped garden were laid out by the poet Alexander Pope at the same time of the building of the house, and over 55,000 trees were planted in 1737 alone. The famous landscape gardener Capability Brown extended the gardens in the 1750s and 1760s and many additional features were added, including a Gothic temple, lodge, serpentine lake and, most famous of all, a Palladian bridge. Designated as a Grade I listed building, the symmetrical and colonnaded bridge was based on the one built at Wilton House in Wiltshire. The approach is spectacular, as it sits nestled in tress at the foot of the valley with the city of Bath in the background. On a fine day it is easy to spend hours meandering around the grounds, looking out for wildlife and taking in the views, and with Bath only a stone's throw away, you are never far from some retail therapy or a relaxing meal.

38. Quantock Hills

The Quantock Hills were the first AONB (Area of Outstanding Natural Beauty) to be established back in 1957, and it is easy to see why. From the rocky Jurassic coastline in the north to dense woodland and exposed summits, the Quantock Hills offer wilderness and tranquillity to all. On good days the views extend for miles, with Glastonbury Tor visible to the east and Wales to the north. During bad weather,

The unspoilt beauty of the Quantock Hills. (Courtesy of Susannah Grant CC BY 2.0)

the views are replaced with a low mist, which shrouds them in mystery. The oak woodlands and ancient parklands are home to many creatures, great and small, and are an important site for red deer, while the heather-, gorse-, bracken- and thorn-covered hilltops create a habitat for all sorts of mini beasts and birds. This is the tip of the iceberg though. With a range of circular walks available, it's possible to splash your feet in babbling brooks, enjoy the tranquillity of vast open spaces and breathe in the sweet smell of pine forests all in one day. The Quantocks have long seen human explorers, with Iron Age hill forts and earthworks dotted across the landscape. Nowadays, there are lots of small village communities nestled in among the hills, each offering a glimpse at remote rural life, and some offering a pub to quench ones thirst. With so much on offer for the senses, it is unsurprising to find out that Samuel Coleridge and William Wordsworth once lived in the area and it is possible to visit Coleridge Cottage in Nether Stowey.

39. Roman Baths at Bath

Somerset is incredibly fortunate to have one of the most significant and well-preserved Roman ruins in the country. After the Roman invasion of Britain, a temple was constructed on the site of geothermal springs that were a centre of worship for the Celts. Rain from the nearby Mendip Hills is heated up by geothermal energy, which forces the water up and out to the surface. With public bathing a staple of daily Roman life on the continent, it isn't surprising that over the next 300 years a full complex was built up, as Roman engineers created stable foundations and constructed building around the hot bath, lukewarm bath and cold bath. The Roman's withdrew from Britain in the fifth century and it seems that the baths fell into a significant state of disrepair. By the twelfth century new buildings were in situ and by the sixteenth century the Queen's Bath was built to the south of the ancient spring by the city corporation. The vast majority of the buildings that we now see were built in the eighteenth century by the father and son architects John Wood the Elder and John Wood the younger, the designers responsible for the iconic honey-coloured Bath stone that most of the city is built with. Every aspect of the Great Bath, aside from its pillar bases, with its columns and symmetrical design was built entirely during this period and the Victorian expansion of the complex saw the town become increasingly popular as a spa town, with many social functions happening here. The Sacred Spring, Roman temple and bath house are all below the modern street level and it is impossible not to feel the heat coming from the calm placid waters within, although sadly no visitors are actually allowed in them due to water safety regulations.

The Grade I listed Grand Pump Room that lies opposite the Roman Baths was completed in 1799. It was the place to go and be seen, with the writer Jane Austen using it as a setting in more than one novel. As a visitor today, the whole complex offers an interesting insight into life in eighteenth- and nineteenth-century Bath, and a small glimmer of Roman Britain nearly 2,000 years ago. The museum has a

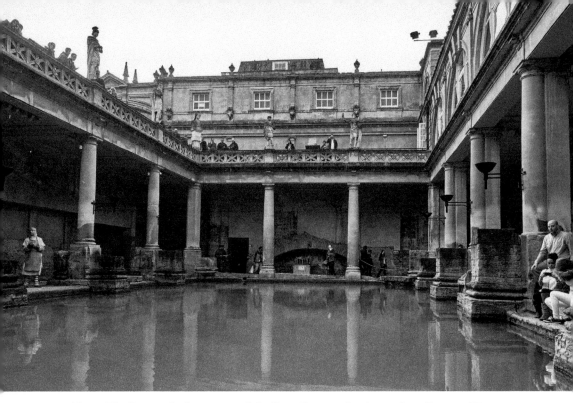

Above: The Roman Baths are one of the finest Roman sites in northern Europe. (Courtesy of Pedro Szekely CC BY-SA 2.0)

Below: Steam rising on a winter's morning. (Courtesy of PapaPiper CC BY-ND 2.0)

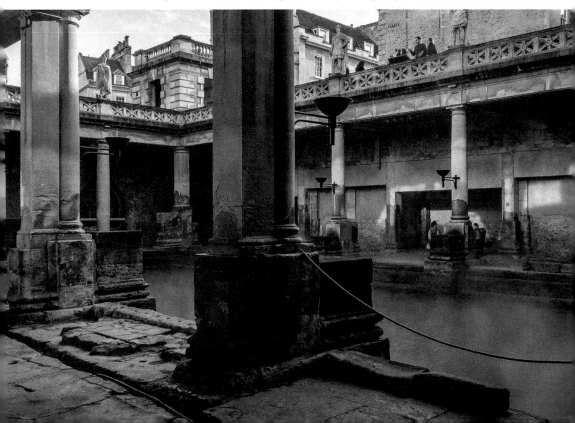

The impressive ancient hypocaust. (Courtesy of AkaJune CC BY-SA 3.0)

whole host of artefacts and objects from the Roman period until the present day, including a host of items that were thrown into the Sacred Spring as offerings to the goddess. The remains of the hypocaust are still visible as are trinkets, carvings and over 10,000 coins. The fact that these public baths are in the middle of Bath certainly adds to the allure of them. Set among the hectic goings-on of modern-day life, the tranquillity offered here is hard to surpass. As one of the greatest religious spas of the ancient world, any visit to Bath isn't complete without stopping here.

40. Shepton Mallet

The historic market town of Shepton Mallet has a lot more interesting aspects to it than you might think at first glance. With the main Roman road into south-west England, the Fosse Way, running through it, it is hardly surprising that there is evidence that the town was originally founded as a Roman settlement and developed its standing as a market town trading the local farmers produce. Shortly after the

Kilver Court Gardens. (Courtesy of Ivor Sutton CC BY 2.0)

Norman Conquest, the town was passed to the Malets, an important Norman family who placed their name after that of the settlement (doing the same to Curry Mallet). In the middle of the town is the Grade II listed market cross, a beautiful octagonal structure that was the central point to life in the town during the Middle Ages, which was constructed in 1500. This was also the rather grisly place, in the aftermath of the Monmouth Rebellion in 1685, where twelve local men from the town were hanged and quartered as a warning to others who opposed the king.

Shepton Mallet's historic prison is another unlikely contributor to the town's attraction. Opened in 1625, it was used right up until the 1930s, primarily for civilians, when it was temporarily closed due to low prisoner numbers. However, at the outbreak of the Second World War it was reopened for British military use, mainly to billet soldiers, but was then handed over to US forces in 1942, who for the next three years used it to incarcerate military personnel who had committed offences. During this time, eighteen service personnel were executed inside the prison. At the same time in a different part of the prison, and unbeknown to most, a number of important historical items from the Public Record Office in London were transported here for their safekeeping during the conflict. Items including the Domesday Book, a copy of the Magna Carta, letters from the Battle of Waterloo and the logbooks of HMS *Victory* were held here until the end of hostilities.

The east end of the town is home to a number of breweries and Kilver Court, originally built as the headquarters for the Showerings brewery (famous for producing Babycham in the town) and later used as the Mulberry leather goods headquarters, is now used as a shopping centre. Behind are Kilver Court Gardens, a 3.5-acre beautifully kept landscaped garden that is open to the public. Created over 100 years ago for the Showerings employees, they are flanked by the disused Charlton Viaduct and the ponds, waterfalls and flowers offer a truly peaceful haven. John Lewis, of department store fame, was born in the town and there are a number of sizeable buildings still standing across the town that confirm Shepton Mallet's inclusion in this list.

41. Steep Holm

Steep Holm is the most remote and probably the least visited gem in this book due to its location 5 miles out to sea in the Bristol Channel. The mile-long island rises up to over 60 metres and is a protected nature reserve and a Site of Special Scientific interest due to the birds and plants that can found there. Visiting the island takes some doing. There are around twelve scheduled days a year where the current owners, the Kenneth Allsop Trust, charter a boat from Weston-super-Mare and these often get booked up quickly. Boats are only able to land on the island at high tide, meaning an early start that is totally dependent on the tides, a twelve-hour stay and a short window to leave at high tide in the evening. Some boat trips arrive at the island to find that it is too rough to land and have to turn back, leaving the potential visitors disappointed but with no other option. It is unsurprising that there is evidence of the island being used during the Iron Age and surveys have suggested there was a watchtower constructed here during the Roman occupation of Britain. It is even said that the Vikings sought refuge on the island before attacking the Somerset towns of Porlock and Watchet in 914. In the twelfth and thirteenth century a small Augustinian priory was established here, with excavations revealing where a 22 metre by 4.5 metre structure once stood. Over the next 400 years ownership of the island changed hands a number of times, with the main people living here being fishermen, who utilised the ruins of the priory building for their own. By the end of the eighteenth century a new cottage was built for the fishermen and in 1832 the island was leased to Colonel Tynte, whose first accomplishment was to construct an inn for sailors, which offered fishing and boating holidays, the ruins of which are still standing. By the 1860s the strategic importance of Steep Holm's location in the Bristol Channel was recognised by the Royal Commission on the Defence of the United Kingdom, with the island being fortified as a Palmerston fort and handed over to military control, lasting until 1908. A limekiln was created to manufacture the mortar needed to build a barracks and four gun emplacements across the island, all of which are now Grade II listed buildings. In 1915 the island was again requisitioned by the Admiralty

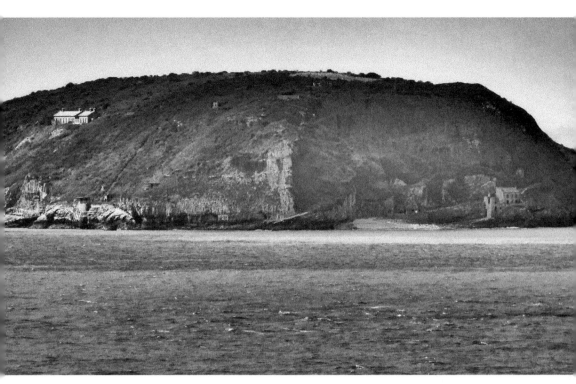

The island of Steep Holm in the Bristol Channel. (Courtesy of Stewart Black CC BY 2.0)

for the remainder of the First World War, this time as a coastguard station, before having search light batteries added. During the Second World War the island again prepared itself to defend the approaches to both Cardiff and Bristol. Since then, the island has been solely used for wildlife. A trip to Steep Holm offers visitors a chance to spend a day away from the hassles and pressures of modern life. This island, in glorious isolation from the rest of the county, has basic facilities and a circular track around the plateau, which allows you to wander around at your own pace, exploring the ruined buildings and spotting the rich variety of wildlife that lives here. It provides simplistic natural beauty with the sound of the waves and the calling of birds as your only soundtrack.

42. Stogursey Castle

Built by the de Courcys family in the twelfth century, Stogursey Castle is a motte-and-bailey designed base surrounded by a water-filled moat. During the First Barons' War it was controlled by King John of England, and the castle inexplicably survived

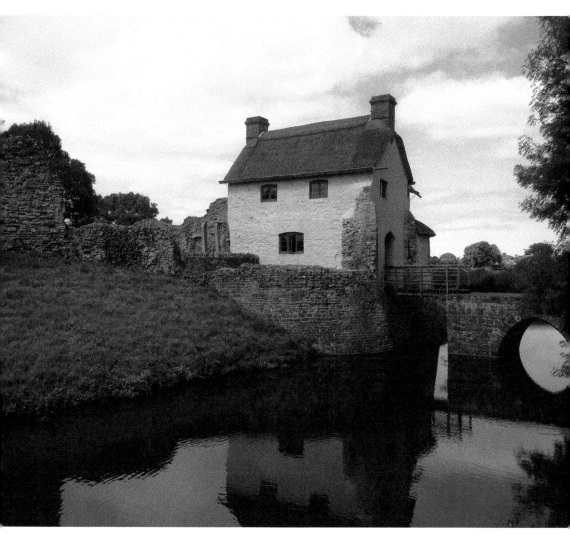

The remains of the motte-and-bailey Stogursey Castle.

two orders for it to be destroyed, first in 1215 and again in 1228. The site was bought and the stone parts of the castle extended by the Fitzpayne family in 1300, who held it for nearly 200 years before it was destroyed during the War of the Roses in the 1450s by the House of York faction. Since then this scheduled monument largely lay in ruins, with there being less of a need for a stronghold in this part of Somerset. Located to the south of the village, it is possible to walk around the outside of the remains. The moat still has water and the gatehouse, which was the least ruined of the castle, was rebuilt and restored by the Landmark Trust into a liveable dwelling, which is now used as a holiday let. Sadly, visiting the site doesn't take long and it is a shame for the explorer in all of us that it is not possible to spend time in among the stone ruins.

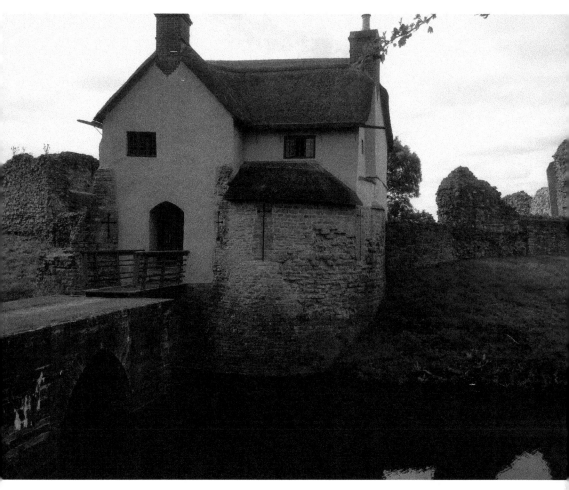

The old gatehouse has now been turned into a comfortable place to stay as a holiday home.

43. Taunton

As the county town of Somerset since 1366, Taunton has to make an appearance on this list. The town's roots go back even beyond the Domesday Book of 1086, with evidence of a Bronze and Iron Age settlement developed at the side of the River Tone. A town of this importance obviously had a castle and the history of this, along with details of its current state as the Museum of Somerset, can be found in a separate entry (No. 34). The town centre has seen many redevelopments over the years, but there are

a number of side streets that still retain some of their old-world charm, particularly in and around the St James' Church area of town. This area is also home to the Brewhouse Theatre & Arts Centre, who have a full diary of events, and the 8,500-capacity County Ground, home to Somerset County Cricket Club, with first-class cricket being played here since 1882. The churches and skyline of Taunton provide a fitting backdrop to the ground that also hosts international matches and open-air music concerts right in the heart of the town. The town also hosts an annual carnival procession through its streets, a highlight of the year for many, with money being raised for local charities in the process. Elsewhere in Taunton, the United Kingdom Hydrographic Office is based in the town and there are a number of public parks, most notable of which is the 1895 created Vivary Park. At nearly 20 acres in size, its proximity to the centre of town means that thousands use its open spaces every week and with golf, tennis, playgrounds, sandpits, adventure activities and ponds it is easy to understand why. Overlooking Vivary Park is a huge red-brick building, which was the keep of Jellalabad Barracks. Built in 1881 by the Ministry of Defence, this military depot became home to the Somerset Light Infantry who saw action in the Second Boer War and it was here at the outbreak of the First World War, thousands

Vivary Park in Taunton.

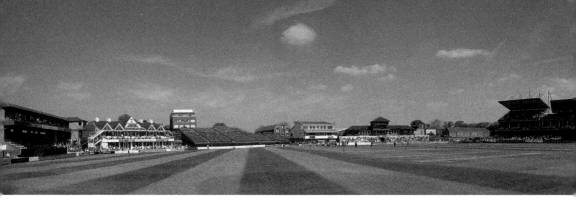

The County Ground is the home to Somerset County Cricket Club. (Courtesy of Ytfc23 CC BY-SA 4.0)

enlisted seeing service on the Western Front as well as in Iraq and Palestine, with almost 5,000 men losing their lives during the conflict. In the Second World War the regiment had men sent to Burma, Italy, Greece and in north-west Europe, participating in D-Day and the Battle for Normandy. Elements were also responsible for defending some of the airfields within the county, such as at RAF Culmhead. After the Second World War, the depot closed and only the keep remained as the regimental pay office. The vast majority of the site was redeveloped for housing, with only this impressive structure remaining. Taunton's stature as the county town has seen a number of other military installations established here. A few miles to the north-west of Taunton lies the village of Norton Fitzwarren, which plays home to Norton Manor Camp, home to 40 Commando Royal Marines. The Royal Army Service Corps began using this new site in 1941 but it was soon handed over to the United States in 1942 to be used as one of their supply depots right up until the end of the war. To the north of the site, the Cross Keys Prisoner of War Camp No. 665 was established in 1941, holding low-security-risk Italian and German prisoners. After the war the depot closed, but the Royal Marines of 40 Commando moved in to the remaining part of the original camp, utilising the nearby territory of the Blackdown and Quantock Hills for training, and, as such, Norton Manor Camp is still in use today. Most recently, over 600 personnel were deployed to Helmand province of Afghanistan as well as providing humanitarian assistance to various locations around the world. Musgrove Park Hospital started its life as the US Army 67th General Hospital during the Second World War in 1941 and many soldiers invalided back from Normandy after the D-Day landings passed through here. After the war the decision was made to keep the facilities built by the US Army and the hospital became part of the fledgling Nation Health Service – something particularly pertinent for me as both of my sons were born here.

44. Wellington Monument

Close to the border with Devon, the town of Wellington is named after Arthur Wellesley, the 1st Duke of Wellington, who helped defeat Napoleon at Waterloo and is regarded as one of Britain's finest military leaders. To commemorate him and

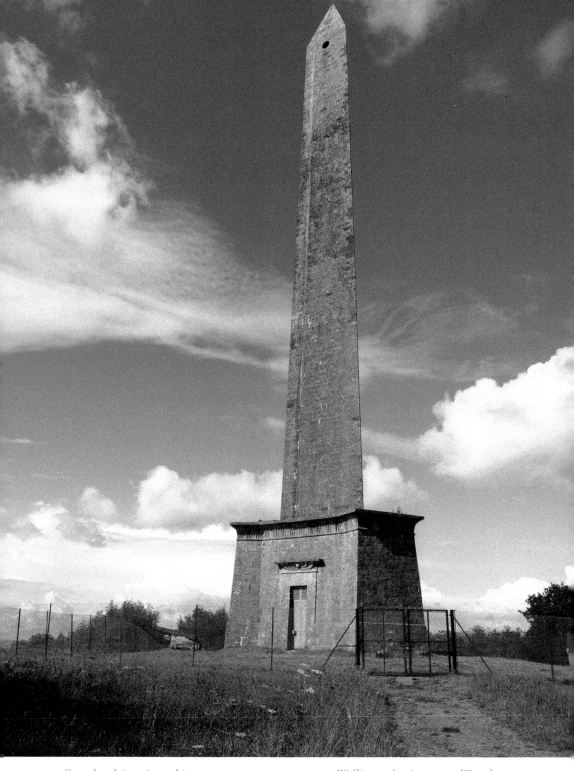

Completed in 1854, this monument commemorates Wellington's victory at Waterloo. (Courtesy of Richard Szwejkowski CC BY-SA 2.0)

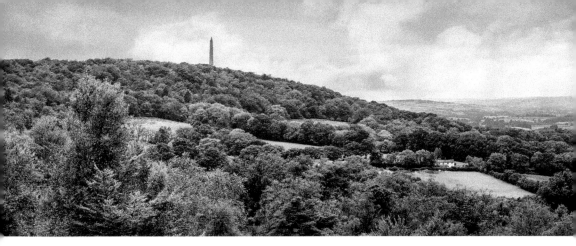

The Wellington Monument overlooks the Blackdown Hills. (Courtesy of Alison Day CC BY-ND 2.0)

the victory at the Battle of Waterloo this 175-foot triangular obelisk was situated at the highest point of the Blackdown Hills overlooking the town. Funded by a public subscription, work began in 1817 but was stopped on three occasions due to a lack of money. Finally completed in 1854, members of the public were once able to climb up an internal staircase to a viewing platform, but this is now closed to the public due to safety fears. However, the short walk from the nearby car park to the monument is worthwhile as the views of the surrounding countryside are still spectacular.

45. Wells

The beautiful cathedral city of Wells, the smallest city in the country, started out as a Roman settlement and grew in importance under the Anglo-Saxons, who built a church here in 704. From then on, the city has spent much of its existence closely linked to the bishops of the diocese of Bath and Wells and the cathedral. This gave the city a strong link to the monarchy and in the English Civil War (1642–51), Parliamentarian soldiers surrounded the city in what became known as the 'Siege of Wells', forcing the Royalists to leave the city. A few years later during the 1685 Monmouth Rebellion, rebels fighting against the king saw the grand cathedral as a symbol of all that was wrong with the 'established order' and attacked it, breaking windows, destroying the organ and using the lead roofing to make bullets. However, the retribution of the king was swift, and Judge Jeffries held the last of his Bloody Assizes in the city, where over 500 of the rebels were put on trial for treason. Lasting just one day, the vast majority were found guilty and sentenced to death on the same cobbled streets you still walk along today. With its population of just 10,000, Wells certainly doesn't feel like a city. It retains its old-world charm thanks to its tiny streets, grand buildings and a feeling that life here moves at a slower pace than the hectic modern world we live

in. Central to this is a walled precinct known as the Liberty of St Andrew, which contains a number of buildings all constructed around 1450, most significant of which is the twelfth-century cathedral. The seat of the Bishop of Bath and Wells, the medieval building stands proudly as the centrepiece to the city. At over 50 metres in height, it dwarfs everything else nearby and its Gothic architecture draws your eyes in.

The inside is as equally impressive and worth visiting. The cloisters, choir stalls and nave are set out impressively, but this cathedral holds other beautiful secrets too. The Lady Chapel, with its stunning stained-glass windows and stellar vault, is reached through the retrochoir, which itself is something to behold with its multitude of angled piers supporting the roof. The octagonal Chapter House holds fifty-one decorated stalls set beneath windows and an impressive fan-vaulted ceiling, and this is reached via some delightful stairs, which are visibly worn down – the impact of centuries of people visiting! The cathedral clock is also worth a mention as it is famous for its twenty-four-hour astronomical dial and a set of jousting knights that

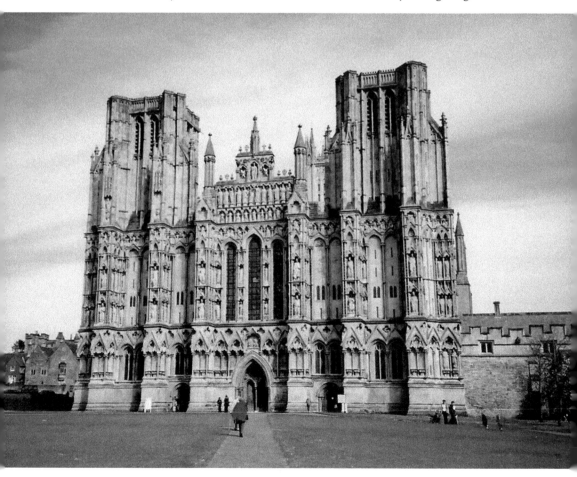

Wells Cathedral.

perform every fifteen minutes. Close by is the Bishop's Palace, which has been the home to the bishops for over 800 years. As well as the great hall, private chapel and gatehouse (with a drawbridge), there are 14 acres of gardens to explore, making Wells a great place to visit.

46. West Somerset Railway

There's something about stream trains that everyone loves; whether they're young or old, people marvel at them. It could be because they offer the opportunity to go back in time to a bygone era, or the chance to get up close to the raw power that they provide. Whatever the reason, the West Somerset Railway had to make the list. As the longest heritage railway in the country, the West Somerset Railway

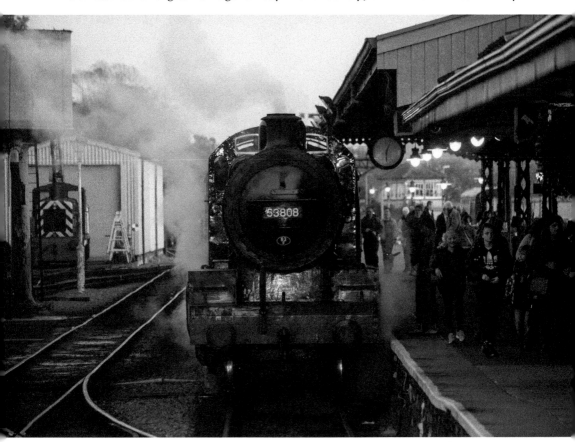

The last train of the day at Minehead station. (Courtesy of Alison Day CC BY-ND 2.0)

allows you to take in all that is glorious about the Somerset countryside along 20 miles of track from Minehead to Bishops Lydeard. Originally opened in 1862 and extended in 1874, the line provided the Victorian and later the twentieth-century traveller with the chance to visit the Somerset coast and have the seaside holiday that was so popular. The influx of money helped Minehead develop and in the sixties the draw was re-emphasised thanks to the Butlins resort. However, as motor transport became more affordable, the railway was closed by British Rail in 1971, before being purchased by Somerset County Council and reopened as a heritage line in 1976. Today, the West Somerset Railway offers the visitor the chance to travel onboard a steam or diesel locomotive and spend a day at any number of Somerset villages or at the seaside in Minehead, before heading back. There are nine stops along the route: Bishops Lydeard, which for many is the main starting point due to its proximity to Taunton and the M5; Crowcombe Heathfield, which offers excellent access to the Quantock Hills; the picturesque thatched village of Stogumber; Williton, which allows access to the 36-mile 'Coleridge Way' across Somerset; the ancient harbour town of Watchet; the village of Washford, which is the location of Cleeve Abbey; the long sandy beach at the quiet seaside village of Blue Anchor; Dunster and its impressive castle; and the aforementioned Minehead. Of course, for many it is all about the train ride, with the destination being an added bonus. Boarding the train at the preserved stations and seeing the puff of smoke come down the line, hearing the hiss of steam and the whistle before clambering on board and chugging off through the countryside, is what makes it such an exciting experience and one which is possible to return to again and again.

47. Westhay

Westhay Moor Nature Reserve might well be another surprise inclusion on the list but for those with a love of the outdoors and wildlife it will be of no surprise. A designated Site of Special Scientific Interest (SSSI), Westhay Moor is part of the Avalon Marshes on the Mendips. Thousands of years ago the site was used as an 'industrial' site of peat workings, and although some peat working still continues, most have stopped and the area has been restored by developing channels, islands and reedbeds, which now make up over 100 hectares of peat moors that are teaming with wildlife. With a clearly signed car park, there are two trails to take: the 3 km otter trail or the 1.6 km coot trail, both of which provide the opportunity to visit the first bird hide and spot a range of birds including herons, kingfishers, egrets and starlings. The site is crossed by the River Brue and Galton's Canal, meaning there is a high water table and therefore there is often flooding across much of the area. This helps to encourage otters, bearded reedlings, marsh harriers and insects to make this their home, which is run by the Somerset Wildlife Trust.

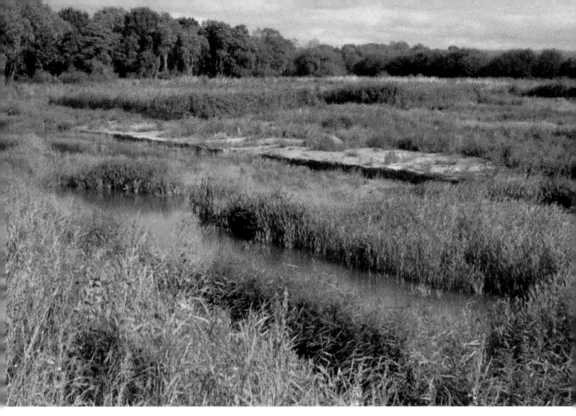

Westhay Moor Nature Reserve. (Courtesy of Ken Granger CC BY-SA 2.0)

48. Weston-super-Mare

Think of Weston-super-Mare and you probably think of the beach and the pier, but it has a lot more to it than first meets the eye. Weston was a small and quiet town of no more than thirty houses up until the nineteenth century when the development of the railways allowed it to grow and develop itself as a Victorian seaside resort, drawing in people from Bristol, Bath, South Wales and the Midlands on family breaks or work outings. The beach is still probably Weston's biggest draw, with the wide expanse of sand providing enough space for thousands to get sand between their toes and take a dip in the sea. However, with the influx of visitors there was an increased demand for entertainment and so Birnbeck Pier was built in 1867 with amusements arcades, rides, tearooms and stalls, and even a photographic studio, although this pier is now sadly in a derelict state. Local traders, however, were unhappy that the holidaymakers weren't coming into the town centre itself and so they took matters into their own hands by raising the funds to build the 350-metre-long Grand Pier closer to the main streets – and their shops. It opened in 1904 and had an impressive 2,000-seater theatre at the end, which was lost to fire in 1930 and then replaced with an undercover funfair. Again ravaged by fire in 2008, it was reopened in 2010 and

remains a huge draw for families as it offers a range of traditional seaside activities, with amusement arcades and rides being top of the list. Another shorter pier housing the SeaQuarium was constructed at the southern end of Weston beach with the aim of bringing more visitors into the town. It offers one of the best aquarium experiences in the south-west. Over the years the seafront and promenade has undergone much updating and improving and this has been integral in keeping day trippers and holidaymakers coming in the twenty-first century.

In 1936, just prior to the Second Word War, RAF Weston-super-Mare was established nearby to the already established station at RAF Locking and this saw the town develop its war industries. After the war, where the town suffered damage at the hands of enemy bombers primarily on the way back from raids to Bristol and the Midlands, RAF Weston-super-Mare remained in use as a supply station and the nearby Westlands Helicopter Factor continued to provide many jobs in the area until it closed in the latter half of the twentieth century. However, as part of the regeneration of the town, in 1988 the Helicopter Museum moved into the existing hangars and has grown ever since, making it the world's largest dedicated helicopter museum with over eighty aircraft on display. The museum includes the preserved former Weston Airport control tower and attached pilots building, which has a fascinating permanent display about the airfield's role during the Second World War. There is also the opportunity to book a ride in a helicopter as one of the Museum's 'Air Experience Flights', making this an attraction to visit time and again.

The Grand Pier at Weston-super-Mare. (Courtesy of Tsaiproject CC BY 2.0)

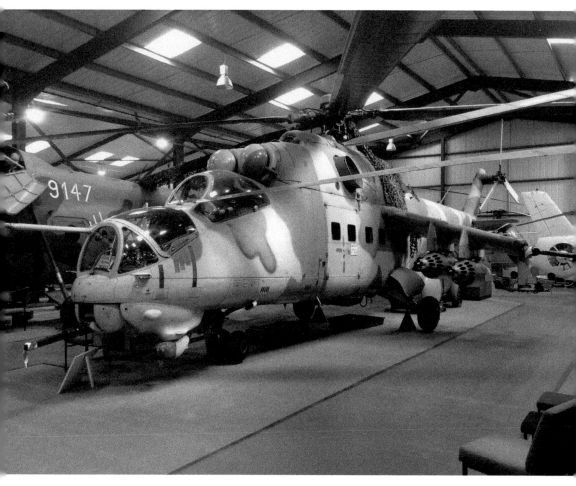

Plenty to see at the Helicopter Museum.

49. Westonzoyland

On the outskirts of Bridgwater lies the small village of Westonzoyland, which has a remarkable history. It was here on 6 July 1685 that the last battle fought on English soil took place – the Battle of Sedgemoor. After a series of fights and skirmishes across the south-west of England, the 3,500–4,000-strong rebel force of James Scott, the 1st Duke of Monmouth, became trapped in Bridgwater on 3 July 1685 by the royal army of James II. The 3,000-strong royal army, led by Louis de Duras, the 2nd Earl of Feversham, set up camp in a field behind the Bussex Rhine at Westonzoyland. Trapped and with nowhere to go, the Duke of Monmouth decided to get on the front

foot and launched a surprise night attack on the king's men. While navigating across the open moorland with its numerous deep and dangerous rhynes, some men startled a Royalist patrol, who in turn alerted the rest of Royalist force. It is no surprise that the professional training of the regular army defeated the ill-equipped rebels, with over 1,200 being killed, compared to approximately 200 of the king's men. Some 500 rebel soldiers were taken prisoner and held in St Mary's Church in the village. Other men were not so lucky, with those found to be hiding being strung up in gibbets along the sides of the village roads as a warning to all who questioned the rule of the king. After initially escaping, James Scott was soon captured in Hampshire and taken to the Tower of London, where he was beheaded. James II sent Lord Chief Justice Jeffreys to round up any of Monmouth's supporters and tried them at Taunton Castle in the Bloody Assizes. Most were found guilty, with the lucky ones being transported abroad, and the rest executed. Today, the village church has a permanent display dedicated to this event and around the village are a series of information boards, along with a walk that leads down to the site of the battle. The isolated farmland remains as it does all those years ago, with a small monument at the spot, and it is now difficult to imagine the bloodshed that once happened here.

The Sedgemoor Inn provides a fantastic place for nourishment before heading out to explore Westonzoyland's other significant site – the remnants of one of the country's oldest airfields. Constructed in 1925, RAF Westonzoyland was used sparingly in the first ten years of its existence, with planes towing targets for the anti-aircraft battery at Watchet to practice on being its main role, but towards the end of the 1930s the airfield was gradually enlarged. During the Second World War, the A372 was closed and diverted south in order to allow the airfield to be significantly

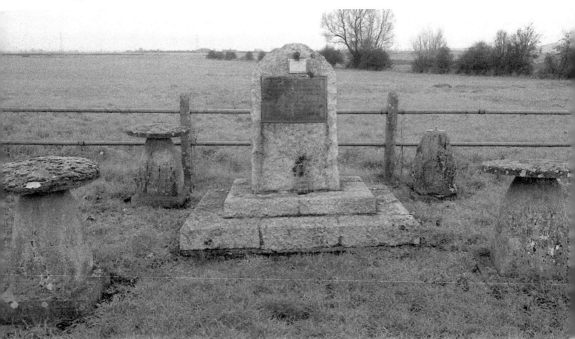

The site of the Battle of Sedgemoor.

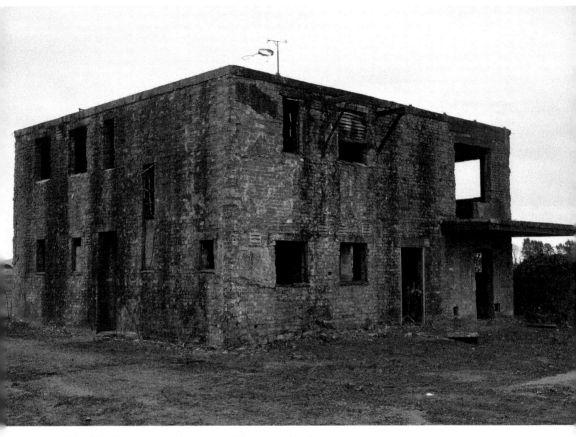

The dilapidated control tower at Westonzoyland.

upgraded to 'bomber standard', with three concrete runways and a whole range of associated buildings being added. With its new status as a Class A airfield, the United States Airforce (USAAF) took control and the 442nd Troop Carrier Group operated from the base using the Douglas C-47 Skytrain to drop troops and equipment into northern France in the months after D-Day until October 1944. From this point until the end of the war a number of RAF squadrons had brief stays at the airfield, with the village becoming accustomed to seeing a whole range of different aircraft coming and going. In the years after the war, RAF Westonzoyland became largely redundant, until the early-mid 1950s, when the Cold War threat saw the airfield once again in use as a training base for aircrews aboard Meteors and Vampires. By 1958 the airfield was once again disused and when it was released from military use in 1968, the A372 was restored to its original location along the route of the main runway. Today, the runways are still evident at the site, as are the derelict remains of the control tower and a whole host of other buildings.

Third on the list at Westonzoyland is Somerset's earliest steam-powered pumping station, which used to keep the Somerset Levels drained and is now a Grade II listed museum.

50. Wookey Hole

The final gem in this book is reserved for the natural caves found at Wookey Hole. However, we start at the village itself, just outside of Wells, which has no less than four Grade II listed buildings. The former paper mill dates from around 1860 and its waterwheel is powered by a small canal from the river. Glencot House is a country house built in 1887. Bubwith farmhouse and, most interestingly, the village post office in the High Street are all protected.

However, it is the Wookey Hole Caves that end our tour. The caves are a series of limestone caverns that have been weathered away by the natural acid in the groundwater. There is archaeological evidence that they have been used for over 45,000 years by humans, with tools, coins and animal remains all being found. In 1927, part of the cave system was opened up to the public as a show cave with three connecting large chambers, all dry and above the water level. In 1975, a one 180-metre-long tunnel was dug out from the third chamber to show visitors the seventh and eighth chambers on bridges before going around the outside of the ninth chamber on a walkway. The rest of the caves are partially or totally submerged in

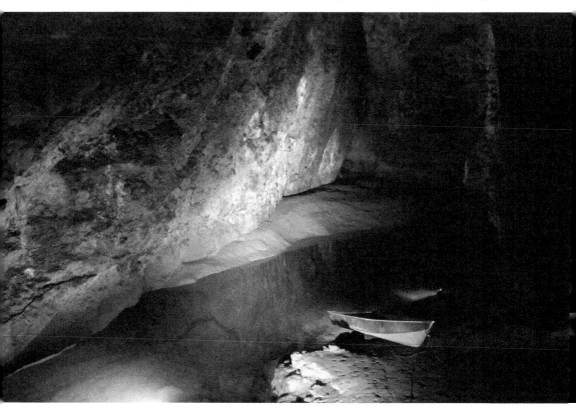

Wookey Hole Caves. (Courtesy of George Regrave CC BY-ND 2.0)

The old paper mill dating from around 1860.

water and were the first cave dives held in Britain back in 1935. To this day, there are many unexplored caves and channels further into the hillside, while the public are content with the dry and lit chambers that still hold a sense of mystery every time you visit them. The mood lighting in there certainly plays its part, as does the rowboat tied to the side, but it is more the calm and quiet in the chambers, with the occasional echo and drip of water, that make them intriguing. Added to this is the legend of the 'witch of Wookey Hole', which is the name given to a human(ish)-shaped stalagmite in the first chamber, said to have been a witch that was turned into stone by a monk. The constant low temperature of the caves means that they can also be used for maturing cheddar cheese, available to buy from the shop, which is the perfect gift to take back home and complete this whistle stop tour of my fifty gems of Somerset.

Acknowledgements

A big thank you to Nick Grant, Jenny Stephens, Marcus Pennington and everyone at Amberley Publishing for their continued help, support and enthusiasm for my writing over the last few years. Thanks to all the people I met on my travels, particularly the owners and staff of the various places, who were so friendly and willing to share their own knowledge. Most importantly, thank you to my wife Laura and sons James and Ryan who accompanied me on many wonderful adventures across the county. Finally, a huge thank you to a range of photographers who have allowed use of their photographs. Any photographs without a credit were taken by the author.

About the Author

Andrew has always had an interest in all things historical but it was only after moving to Somerset in 2013 that he began writing. Passing a pillbox on the way to work every day was the spark he needed, discovering it was part of the Taunton Stop Line, but that there was very little written about the subject. As he found more and more pillboxes and defences scattered across the region, Andrew decided to 'write the book he'd like to read' and so began eighteen months of research and exploration, culminating with the publication of *The West Country's Last Line of Defence: Taunton Stop Line* in April 2017 with Amberley Publishing. During this time it was clear that his new home of Somerset has a vast range of military history from Iron Age hill forts to the Cold War, and so began his next project, *Somerset's Military Heritage*, which was published in April 2018, again with Amberley.

Andrew lives in Somerset with his wife and two young boys. He works as a primary school teacher and is also proud to have had children's fiction books published. Andrew has been on BBC Radio Bristol, and has been a guest speaker and lecturer at a number of events. With more books and events planned, it is possible to keep up with everything he is up to by following him on social media or by visiting his website at www.andrewpowell-thomas.co.uk.

Also available from Amberley Publishing

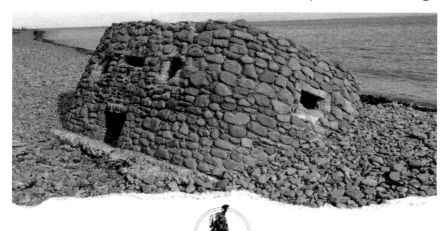

SOMERSET'S
MILITARY HERITAGE
ANDREW POWELL-THOMAS

This book will be of interest to all those who would like to know more
about Somerset's remarkable military history.
978 1 4456 7698 2
Available to order direct 01453 847 800
www.amberley-books.com